2009 RENWICK CRAFT INVITATIONAL
staged stories

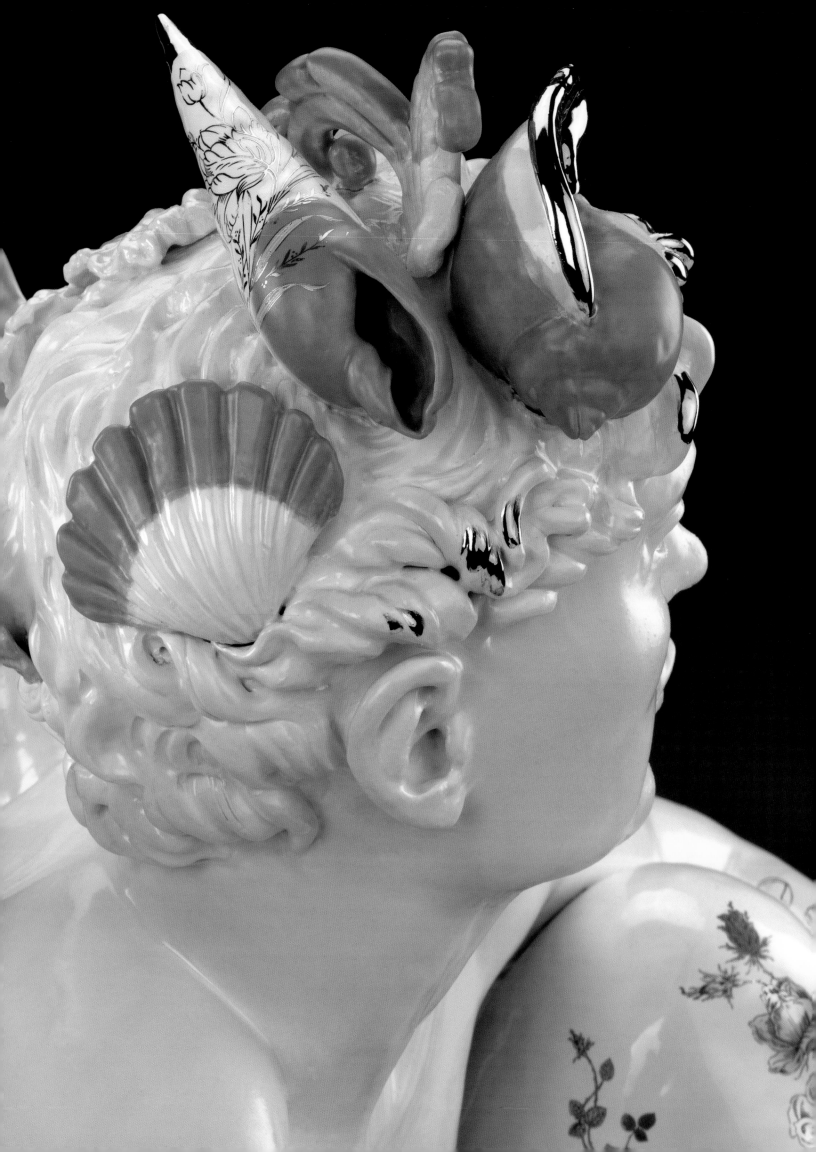

2009 RENWICK CRAFT INVITATIONAL
staged stories

written by
Kate Bonansinga

foreword by
Elizabeth Broun

Renwick Gallery of the
Smithsonian American Art Museum
Washington, D.C.

in association with
Scala Publishers Ltd

Staged Stories: Renwick Craft Invitational 2009
By Kate Bonansinga, with foreword by Elizabeth Broun

Chief of Publications: Theresa J. Slowik
Editor: Tiffany D. Farrell
Designers: Robert Killian, Jessica L. Hawkins

Published in conjunction with the exhibition of the same name, on view at the Renwick Gallery of the Smithsonian American Art Museum, Washington, D.C., August 7, 2009–January 3, 2010.

Smithsonian American Art Museum
Renwick Gallery

The Renwick Gallery of the Smithsonian American Art Museum collects, exhibits, studies, and preserves American crafts and decorative arts from the nineteenth to twenty-first centuries. Housed in a historic architectural landmark on Pennsylvania Avenue at 17th Street NW, the Renwick features one-of-a-kind pieces created from clay, fiber, glass, metal, and wood.

The Smithsonian American Art Museum is home to one of the largest collections of American art in the world. Its holdings—more than 41,000 works—tell the story of America through the visual arts and represent the most inclusive collection of American art in any museum today. It is the nation's first federal art collection, predating the 1846 founding of the Smithsonian Institution. The museum celebrates the exceptional creativity of the nation's artists whose insights into history, society, and the individual reveal the essence of the American experience.

For more information or a catalogue of publications, write: Office of Publications, Smithsonian American Art Museum, MRC 970, PO Box 37012, Washington, DC 20013-7012

Visit the museum's Web site at AmericanArt.si.edu

Cover: Mary Van Cline, *Cycles of Relationship of Time* (detail), 2000. See p. 51.

Back cover: Mark Newport, *Freedom Bedcover: Zachary* (detail), 2006. See pp. 40–41.

Frontispiece: Christyl Boger, *Waterwings* (detail), 2007. See p. 19.

Facing foreword: SunKoo Yuh, *Can You Hear Me?* (detail), 2007. See p. 71.

Library of Congress Cataloging-in-Publication Data

Renwick Craft Invitational (Exhibition) (4th : 2009 : Washington, D.C.)
 Staged stories : 2009 Renwick Craft Invitational / written by Kate Bonansinga ; foreword by Elizabeth Broun.
 p. cm.
Published in conjunction with an exhibition on view at the Renwick Gallery of the Smithsonian American Art Museum, Washington, D.C., Aug. 7, 2009-Jan. 3, 2010.
Includes bibliographical references.
ISBN 978-1-85759-617-5 (softcover : alk. paper)
1. Decorative arts--United States--History--21st century--Exhibitions. I. Bonansinga, Kate. II. Renwick Gallery. III. Title. IV. Title: 2009 Renwick Craft Invitational.

NK808.2.R45 2009
745.0973'074753--dc22

2009007995

Published in 2009 by the Smithsonian American Art Museum in association with

Scala Publishers Ltd
Northburgh House
10 Northburgh Street
London EC1V 0AT

Printed and bound in Singapore.

contents

foreword

The *2009 Renwick Craft Invitational* tracks a sea change in craft art. The four artists in *Staged Stories* depart in significant ways from the sixty-year traditions of the studio craft movement that emerged after World War II. That movement was also a liberation, combining new industrial processes with an open, modern sensibility in fresh ways that overcame exhausted decorative art expressions of the Victorian and Edwardian eras. Today a similar, fundamental shift is occurring.

The artists in the *2009 Invitational* are allied to long-standing craft traditions in their mastery of materials—clay, glass, fiber—but each discards the baseline rationale of crafts—their functionality. Performance and theater are more urgent inspirations, signaling a new orientation in a fertile aesthetic crosscurrent. Kate Bonansinga, Jane Milosch, and Paul Smith, who selected the participants, unite in this *Invitational* four very different artists who share a novel view of the roles their art plays on the world stage.

Mary Van Cline uses photography to project actors and landscapes onto large glass environments reminiscent of Japanese theatrical architecture. Christyl Boger makes nude figures that hover uneasily between Greek sculpture, Meissen palace porcelains, and Jeff Koons's ironic ceramic figurines; her figures are classical actors in an unstable world. SunKoo Yuh tackles tough contemporary issues with the insight of a traveler across multiple universes; his Korean background informs a personal script for the surreal theaters of war and religion. Mark Newport knits new costumes for yesterday's superheroes that

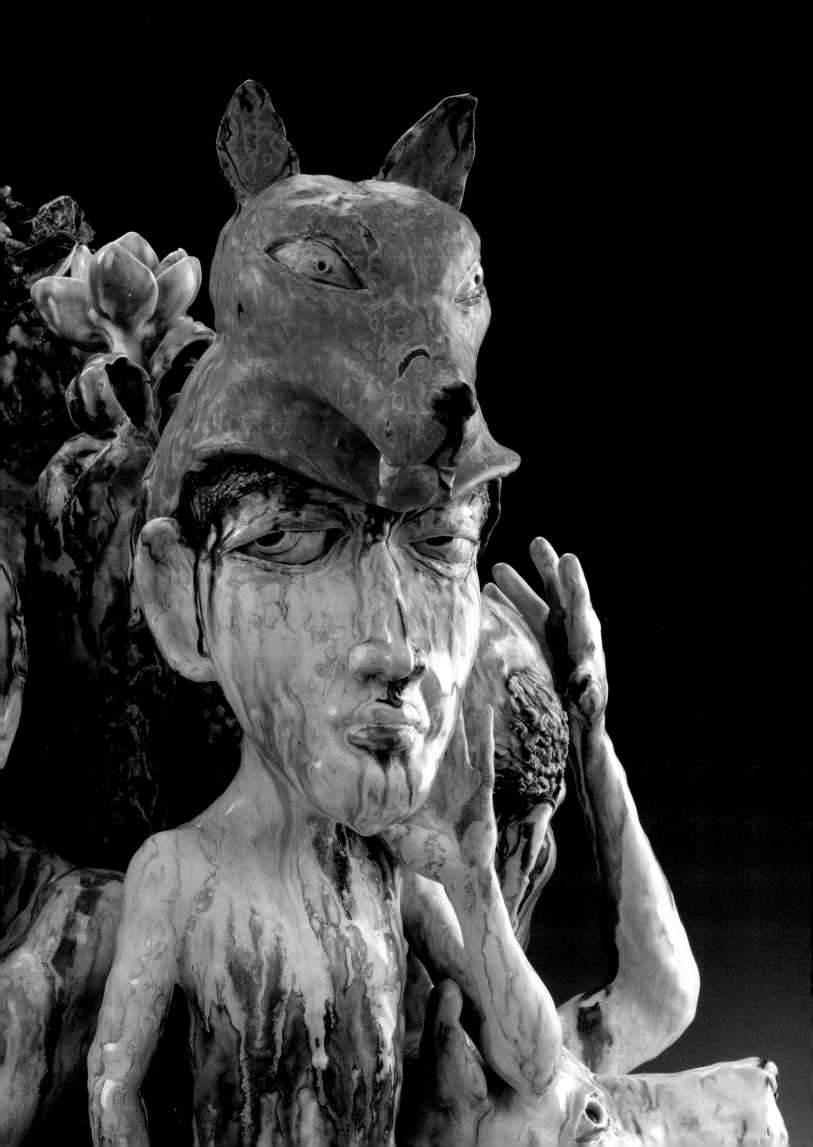

emblemize today's sagging power dreams, when Krypton no longer vanquishes any evil. Here, art is not a static object for contemplation, but rather performs for a curious contemporary audience. The stages may derive from Japanese Noh theater, Greek drama, Bernini's baroque fantasies, Hollywood movies, or even TV thrillers, where the dramatis personae are pulled from comic books. All rehearse contemporary experience in a way that dramatizes meaning, as author and curator Kate Bonansinga insightfully reviews in this catalogue.

This exhibition is a mile marker along the ever-twisting path of crafts that began in prehistory. Physical materials remain a touchstone through time, ever willing to express a new direction when reshaped by new ideas. But today's craft artists have a political awareness and high ambition that aims to overcome the long marginalization of craft art. Craft is still trapped in separate marketing structures, but museums and collectors increasingly embrace these art forms with exciting exhibitions and collections, alongside painting and sculpture. By positioning their work within the arenas of performative art, these craft artists confound old categories and break barriers.

The *Renwick Craft Invitational* series is itself a stage for biennial "performances" by artists who are defining the way craft materials express fundamental human concerns. The Ryna and Melvin Cohen Family Foundation Endowment generously supports this ongoing series, reflecting a strong commitment to the craft field. Because this endowed exhibition series guarantees a steady booking for major craft

art developments every two years, the *Invitational* is emerging as a significant force in the field. The path it tracks in future years will not be straight, for craft art is always responsive to new ideas and competing directions, but it promises to be entertaining and full of discoveries for all audiences.

ELIZABETH BROUN
The Margaret and Terry Stent Director
Smithsonian American Art Museum
December 2008

acknowledgments

There are many people who have supported this exhibition in its various stages of planning and execution. Of those, I want to mention a few. Jane Milosch, curator of the Renwick Gallery, invited Paul Smith, director emeritus of the American Craft Museum (now the Museum of Arts and Design) in New York, and me to help select the artists to be invited. Milosch then recommended me as guest curator for the exhibition. I thank her for that vote of confidence and for her ongoing guidance and friendship. I also thank Robyn Kennedy, chief of the Renwick Gallery, and Betsy Broun, the Margaret and Terry Stent Director of the Smithsonian American Art Museum, for endorsing Milosch's recommendation. They also brought their expertise to the planning of this exhibition.

The four artists—Christyl Boger, Mark Newport, Mary Van Cline, and SunKoo Yuh—gave me their time during extensive in-person interviews and through follow-up correspondence. Their talent is evident in the works on view, and the world is a better place for their commitment to their artistic practice.

Lenders to the exhibition include Helen Williams Drutt English and H. Peter Stern, Patricia Schaefer and Tove Stimson, Laura Lee Brown and Steve Wilson, Greg Kucera Gallery, and Leo Kaplan Modern, all of whom deserve our gratitude for sharing works from their collections.

My colleagues at the University of Texas at El Paso—including Diana Natalicio (president), Howard C. Daudistel (dean of the College

of Liberal Arts), members of the faculty of the Department of Art, and the staff at the Stanlee and Gerald Rubin Center for the Visual Arts—have provided support throughout the process of curating this exhibition. Nicholas Bell at the Renwick Gallery kept everything on track; Rebecca Robinson, also of the Renwick, provided administrative support. All have my thanks.

For the publication, three anonymous readers encouraged me to refine my interpretations of the art to be deeper and more insightful. I thank them for challenging me to do better. Graduate student intern Josephine Shea did an exceptional job of authoring the artists' biographies and is also responsible for coining "staged stories," the title of the exhibition. Editor Tiffany Farrell provided invaluable input on improvements for the essays. Again, thanks to all.

And finally, my husband, David, and my parents and sisters are constant sources of support and encouragement.

KATE BONANSINGA
Director and Chief Curator
Stanlee and Gerald Rubin Center for the Visual Arts
University of Texas at El Paso

introduction

In summer 2007, Jane Milosch asked Paul Smith and me to work with her to select the artists for the *2009 Renwick Craft Invitational*. As the three of us discussed various qualified artists and how their work would interact conceptually and visually, we identified some common pursuits among craft artists today. These include craft as installation art, craft and technology, craft with a sound component, and craft and staging, wherein the art object conveys a narrative based in fantasy and usually occupies a space apart from our own. We settled upon craft and staging and chose four midcareer artists. Christyl Boger is in the early period of that phase; Mark Newport and SunKoo Yuh are firmly at its center; and Mary Van Cline is nearing late career. Each of these artists is rooted in the history of his or her medium and is aware of how that history lends meaning to the art. Yet each pushes the material away from function, shaping it to communicate in new ways.

In 1967, Michael Fried's highly influential essay *Art and Objecthood* explored what he called "literalist" art that has "a theatrical effect or quality—a kind of stage presence."[1] Though Fried was discussing minimalist art, his exploration of the staged presence of an object is also applicable to narrative craft, such as that exhibited here. All four of these artists use elements of theater, including props and artifice (Boger and Van Cline), costumes (Newport), and mise-en-scène (Yuh and Van Cline) in the conceptualization and presentation of their art. Current discourse on contemporary art examines

theatrical strategies, but usually focuses on performance art and its documentation in photographs. This exhibition, on the other hand, explores theatrical devices in object-oriented art.

The ceramic sculptures of Christyl Boger, for example, reference traditional gilded ceramic figurines, but subvert association with domestic décor due to their relatively large scale and contemporary props. Their facial expressions imply self-involvement and make them seem ill equipped to exit their make-believe world. The theory of the gaze in art and theater contends that the male looks and the female is observed. Boger's sculptures receive the viewer's gaze, which is, according to this theory, male regardless of the viewer's gender.[2] They also return it. Fried points out that theatricality in art depends upon the viewers' "experience of being distanced by the work."[3] Boger's figures distance us with their stares. Using Fried's essay and the theory of the gaze, her works become idealized objects of our desire.

Mark Newport knits costumes for superheroes who have been immortalized in television and cinema, today's most pervasive media for conveying theatrical narratives. Some characters are familiar, such as Batman and Raw Hide Kid, and others are invented by Newport, such as Sweaterman. The suits allude to invincibility, but their soft, porous construction falls short of providing true protection. The works consequently investigate the implausible aspirations of the superhero. Newport questions social expectations of masculine behavior by

mixing subjects typically associated with adolescent males, such as comic book heroes, with craft techniques most closely associated with women, such as beading, embroidery, and knitting.

Mary Van Cline employs sheet glass and pâte de verre to construct sculptures that incorporate black-and-white photographs of figures, sometimes draped and masked, backdropped by scenes that range from natural to architectural. She depicts anonymous females in archetypal landscapes that are dramatic but ambiguous. Like an audience in a theater, we suspend disbelief, aware of the artifice but nevertheless drawn in by it.

SunKoo Yuh piles figurative representations in ceramic sculptures that compress multiple stories into a single narrative. Buddha, Jesus Christ, signs of the Chinese lunar calendar, present-day soldiers, and myriad other characters are blanketed in glazes of various colors and opacities, which Yuh applies in a manner that is loosely reminiscent of the dripped glazes of China's Tang artisans. Each sculpture can be connected to theater of the absurd in its unlikely juxtaposition of characters and its emphasis on the inexplicable. All of Yuh's actors simultaneously inhabit a stage in an explosive multicultural extravaganza.

It can be argued that figurative art in general, which dates to prehistory, has a dramatic effect because humans identify closely with representations of like beings and become involved in the stories they tell. Boger, Newport, Van Cline, and Yuh are unified in their focus on

the deliberate theatricality of their figuration and on their reference to various modes of storytelling. All are connected to the history of their media and use this connection to strengthen the ideas conveyed in their art. Boger studied baroque palace porcelains such as Meissen and Sèvres; Newport recognizes that knitting is historically allied with women's work and uses this association to burst open gender stereotypes; historical Asian painting and ceramics are Yuh's muses; and Van Cline photographs with an antique Hasselblad film camera to create black-and-white images of dreamlike environments. How these artists employ disguise and staging, and lend them meaning, is the subject of this exhibition.

Note to the reader: In dimensions noted throughout, height precedes width and depth, where appropriate.

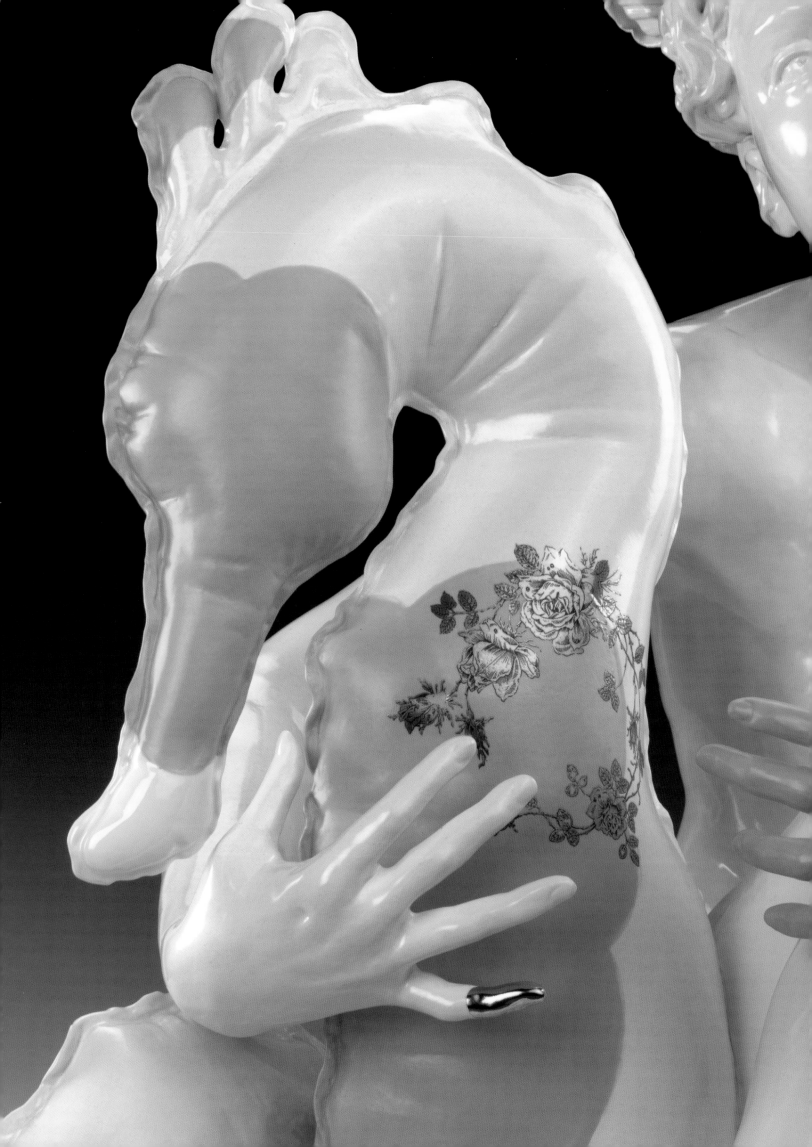

christyl boger

Flowers in full bloom and fantastic ice sculptures were Christyl Boger's tools in her previous career as an event planner, when she temporarily transformed convention center ballrooms and country club lawns into places of magic and entertainment. Boger describes the centerpieces as important components of the orchestrated events: "Thousands of dollars of fresh flowers from all over the world; beautiful, live things, used in service of an idea for just a few hours."[4] Perhaps not coincidentally, "centerpiece" is one term Boger uses to refer to her recent ceramic sculptures, most of which depict a singular idealized figure accompanied by a rendition of an inflatable aquatic toy. The pool toys are playthings,

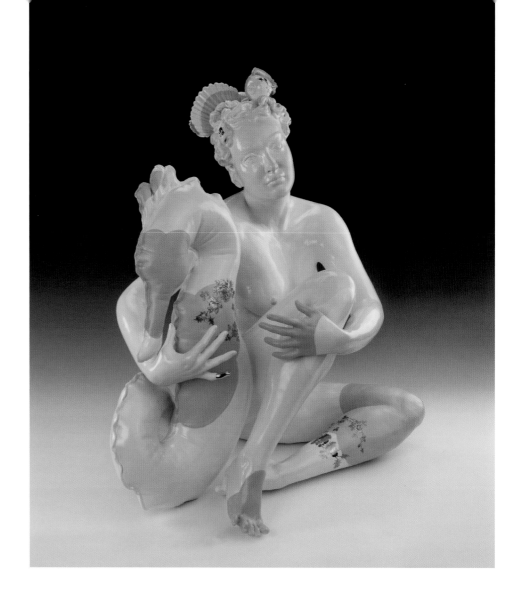

the type that does not assure buoyancy in times of crisis, and emphasize the figures' vulnerability. So do their crouched positions, which make them seem like they are attempting to hide from the viewer's gaze, exposed rather than empowered by their nakedness. Each is a union of the classicism of Greek figurative sculpture and the contemporary kitsch of pool party props. Boger borrows freely from sources ranging from high art to popular culture to create works that confront the viewer, each commanding its own space made more dynamic by its gaze.

During graduate school Boger was introduced to European palace porcelains of the seventeenth and eighteenth centuries, such as Meissen and Sèvres, status symbols of the wealthy, whose coded conduct was

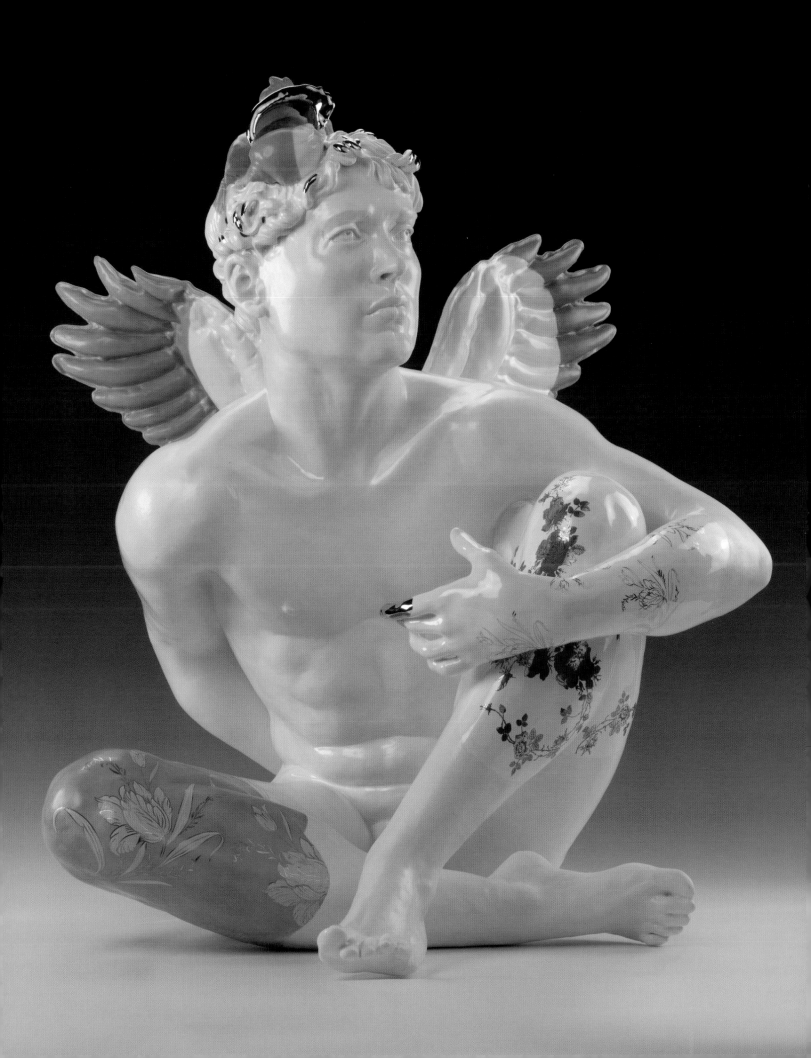

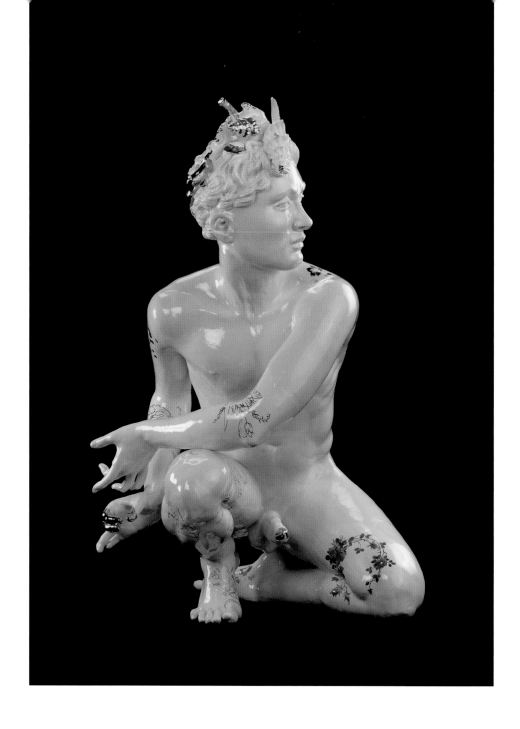

Weekend State, 2005,
glazed white earthenware
with gold luster,
30 x 18 x 18 in.
Collection of Laura Lee
Brown and Steve Wilson;
Louisville, Kentucky

often layered with artifice. She was fascinated by these narrative works, which are imbued with clues about historical dress and social hierarchy. Social mores established centuries ago impact human interaction today, which Boger describes as "the animal body overlaid by the veneer of cultural constraint."[5] Boger's figures are, on the contrary, without veneer, naked. In the late 1990s her sculptures were smaller in scale than they are today and more heavily decorated with surface decals and three-

dimensional, repeated clay flowers or other patterned forms. Recently the artist has eliminated much of the ornamentation and explains, "The form and content are so inextricably linked that you don't need surface decoration." Instead she applies tiny areas of luster to select fingers and toes and other body parts, like insubstantial costumes that emphasize the figure's defenselessness. The scale of the works exhibited here places them between life-size sculpture and small, decorative objects, between high and low art, unintimidating but not easily ignored. With the intensity of their gazes they command space and "*confront* the beholder," to quote Michael Fried in his description of the theatricality of art objects.[6] They become actors who challenge us to enter their stage.

Boger's father is a psychologist and has influenced her work. The artist invests her figures with a Freudian state of repressed longing that seems to stir from behind their vacant stares. Sigmund Freud, the father of psychoanalysis, surrounded himself with ancient figurative sculpture, and feminist art historian Griselda Pollock argues that Freud's ownership of the sculpture was in part to relieve the anxiety of being constantly looked at by eight patients each day.[7] Through sculpture, he reasserted his own power of observation and solidified his role as authoritative analyst. His "analytical theater [was] a complex space of dislocated vision" where doctor, patient, and sculpture coexisted, each the subject of the other's gaze.[8] Boger capitalizes on this theatrical exchange of stares. Each figure stares both outward and inward, observing both viewer and self. Scholars of theater have discussed the concept of emptiness as it

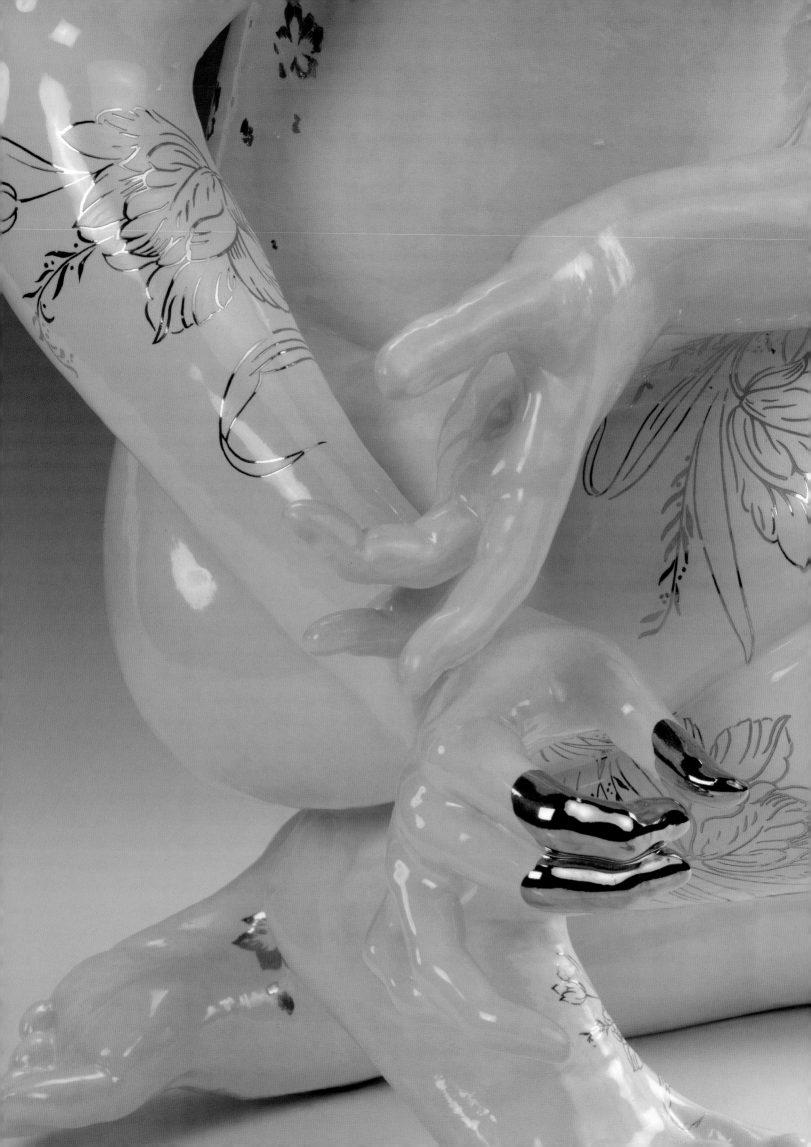

Weekend State (detail),
2005. See p. 20.

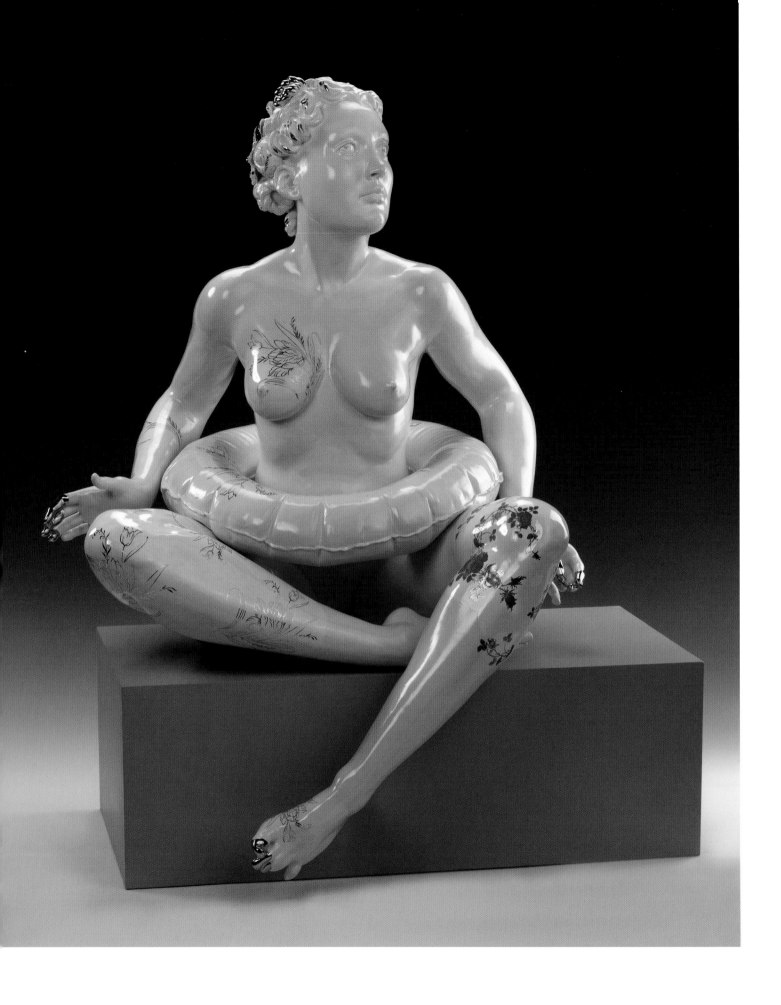

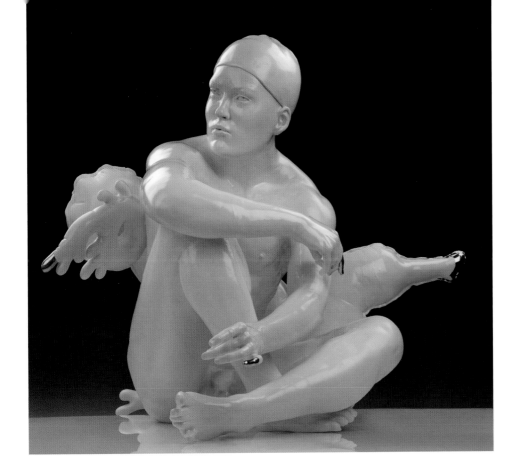

is reflected by and coincides with the emptiness of the stage space.

Likewise, psychoanalysis recognizes the primordial void underlying our

consciousness.[9] Boger's figures are literally hollow and emphasize this idea.

The artist uses a ceramic rib, a flat tool that fits snugly into the

hand, to form the coil-built structure from the inside out. She usually

builds one sculpture at a time, from start to finish, in white earthenware,

beginning with the torso, which establishes the scale for the other body

parts. She then covers the completed form with a glossy glaze.[10] The

hollow figures seem encased in glass, unreachable behind this reflective

glossiness, a material quality that affirms Boger's contention that social

validation requires being seen and apprehended by another. As social

beings, we depend upon the affirmation of others to lend meaning

to our existence, even if that acknowledgment is based on superficial

interactions. Plus, Boger claims her material "stays true to the language of

ceramic figurines. People have suggested that I make these in bronze, but

◁

Float, 2006, glazed white
earthenware with gold
luster, 32 x 22 x 22 in.
Collection of Laura Lee
Brown and Steve Wilson;
Louisville, Kentucky

Figure with Sea Dragon,
2008, glazed white
earthenware with gold
luster, 27 x 20 x 16 in.
Collection of the artist

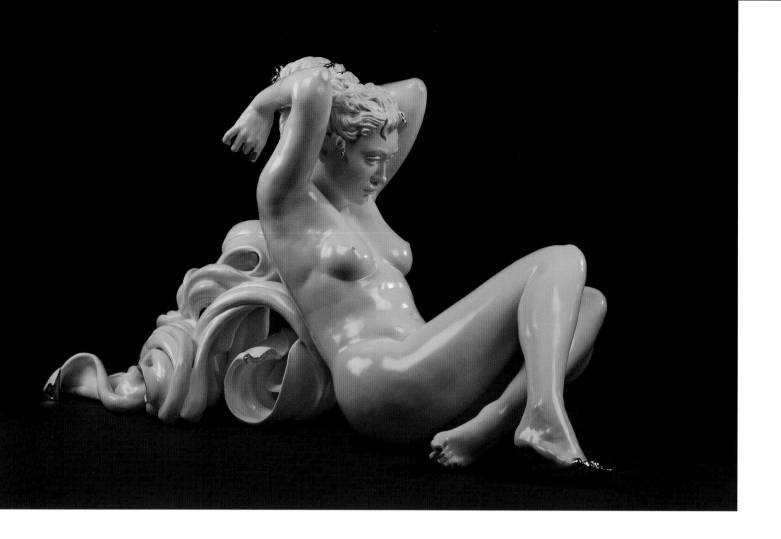

Day and Night, 2008,
glazed white earthenware
with gold luster,
26 x 54 x 19 in.
Collection of the artist

bronze would have nothing to do with anything. . . . The material of clay itself is inseparable from the ideas" of fragility and artifice.[11]

Boger's studio is populated by inflatable pool toys, and pinned to its walls are photocopies of images of Gianlorenzo Bernini's baroque sculptures, including *Ecstasy of Saint Teresa* and the Triton Fountain in the Piazza Barberini in Rome. In the latter sculpture, the sea god is represented as a merman who rises up above an open shell supported by dolphins. Boger also displays the dust jacket for Robin Hildyard's book *English Pottery, 1620–1840,* which is printed with an image of a miniature blue-and-white porcelain deer. Boger's exploration of the opulent and dramatic visual products of the baroque period crisscrosses back and forth between Bernini's sculpture—serious, large-scale, dramatic in facial expressions and gestures, often religious in content and commissioned for places of worship

and public plazas—and figurative ceramics by unknown makers—small-scale, more personal in content, and created for domestic environments. The latter are the predecessors of more recent kitsch figurines. Because Boger's expressive but idealized figures combine the drama of the baroque, the proportional perfection of classicism, and the tabletop scale of decorative figurines, they walk the line between high and low art.

Day and Night and Night and Day (both 2008) are based on the nude figures representing Day (male) and Night (female) as carved by Michelangelo in the early sixteenth century for Giuliano de' Medici's

Night and Day, 2008,
glazed white earthenware
with gold luster,
26 x 54 x 19 in.
Collection of the artist

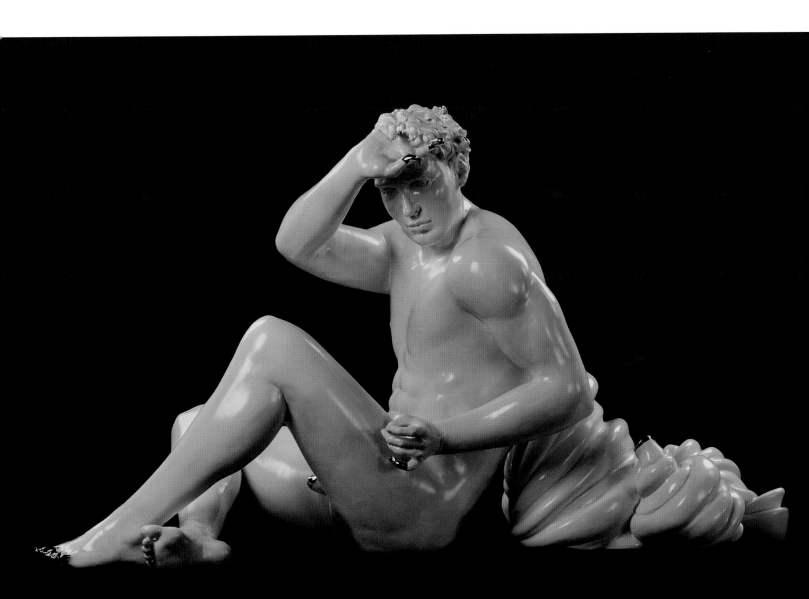

Day and Night (detail), 2008.
See p. 26.

▷
Figure with Dolphin, 2007,
glazed white earthenware
with gold luster,
27 x 24 x 18 in.
Collection of the artist

tomb in Florence. Unlike other figures by Boger, these recline rather than crouch, implying confidence. Drapery is their backdrop, alluding both to a theater curtain and to the enrobed *Ecstasy of Saint Teresa* by Bernini. Over the course of her career Boger has created twice as many female figures as male ones. As a female artist, she upsets the paradigm of the male gaze co-opting the female body because she depicts the male body from a female perspective. "I'm not trying to create authentic masculine identity, but rather a reflection of how I look at the masculine body," a twist on Michelangelo's male interpretation of the female form. Michelangelo lived during the Renaissance, a period of renewed interest in ancient Greece. His perspective links back to classical Greek theater, which required female impersonation.[12] Michelangelo strove to achieve "a new ideal of beauty," and Boger follows his lead by depicting and objectifying a feminized male, an unreachable entity to be admired and desired, staged apart from the everyday world.[13]

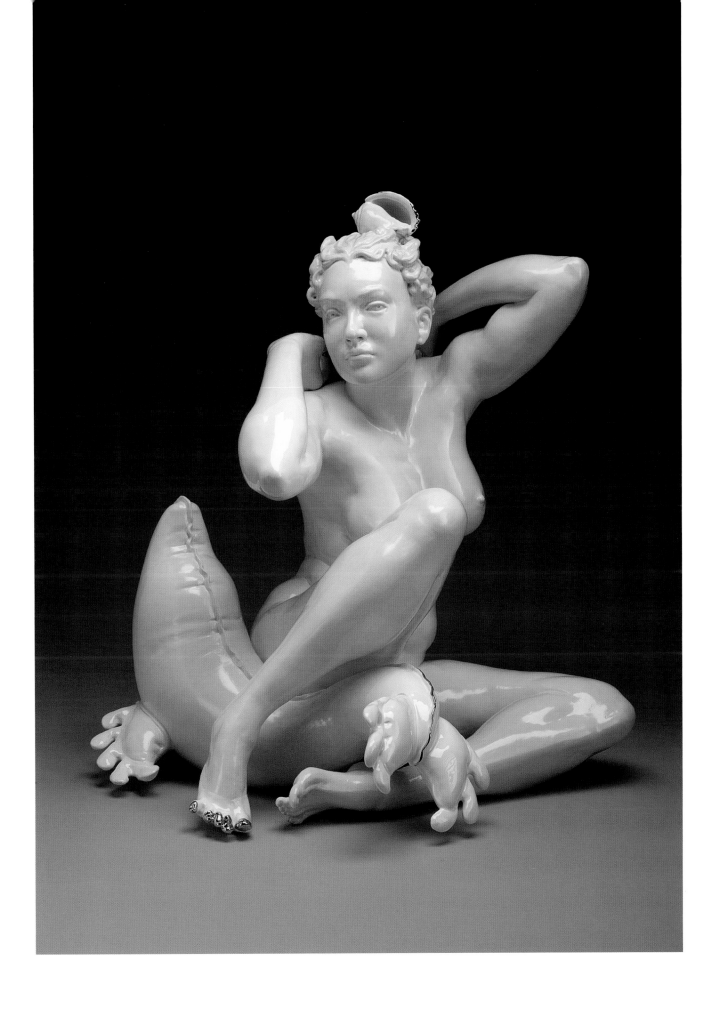

mark newport

Mark Newport knits costumes for superheroes such as Batman, Superman, Spiderman, and other protagonists of pre–World War II comic book narratives. These characters were reincarnated in television series beginning in the early 1950s and then again in blockbuster movies from the 1970s onward. Newport also knits suits for heroes of the fictionalized American West, another popular subject in cinema and television.[14] Consequently, the stage for Newport's characters is Hollywood sets. The artist also performs, which usually involves his knitting in public while wearing one of his costumes. He enters the everyday arena transformed by one of his hand-knitted suits; the most quotidian locale has the potential to be his stage.[15]

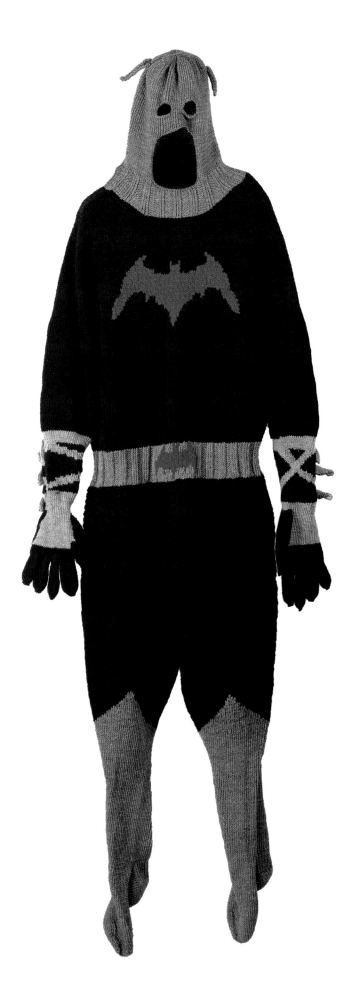

Newport learned to knit from his grandmother when he was young, and then to weave in Brazil when he was a high school exchange student. By the time he graduated from the Kansas City Art Institute in 1986 he was creating tapestries of images from sports magazines, the first visual expressions of his interest in gender roles as depicted in popular culture. After college he moved back to the East Coast, where he grew up, and worked in the gift shop at the Wadsworth Atheneum Museum of Art, in Hartford, Connecticut, where the curator of textiles asked him to demonstrate artist Jane Sauer's half-hitch knotting technique to groups of docents. This opportunity proved to have a lasting impact. A few years later Newport exhibited knotted figurative sculpture for his graduate school thesis show at the School of the Art Institute of Chicago. He continued working in this vein until the mid-1990s, when he shifted to using trading cards as a canvas, decorating parts of pictured sports personalities with colorful, sparkling glass beads, feminizing these icons of masculinity. By this time he was a member of

the faculty at Western Washington University in Bellingham, where in the year 2000 he rekindled his passion for knitting in order to expand the repertoire of techniques that he brought to the classroom. In 2002 he began knitting full-body costumes.

Newport is a child of the television age; even today he watches kitsch productions such as *Buffy the Vampire Slayer* while he knits. Television infused the postwar American household with Hollywood drama and comedy; this inherently populist medium brought theater to the masses. Popular culture is Newport's arena, and the characters of its narratives become the subjects of his art. Knitting, too, is more readily associated with craft than high art, so Newport's lowbrow medium affirms his message about the influence and pervasiveness of popular entertainment such as comics, TV, and the movies. He further emphasizes the lowbrow by using cheap acrylic yarn. In the past five years, knitting has surged in popularity among men and women of all ages. According to the *New York Times*, "some four million people in the United States have taken up knitting since 2003."[16] Newport was just ahead of the curve in this knitting revival.

◁◁
Every-Any-No Man
(detail), 2005. See p. 34.

◁
***Batman 2*, 2005,**
acrylic yarn and buttons,
72 x 26 x 6 in.
Courtesy of the
Greg Kucera Gallery

***Batmen*, 2005,**
photo inkjet print
on paper, 13 x 19 in.
Courtesy of the
Greg Kucera Gallery

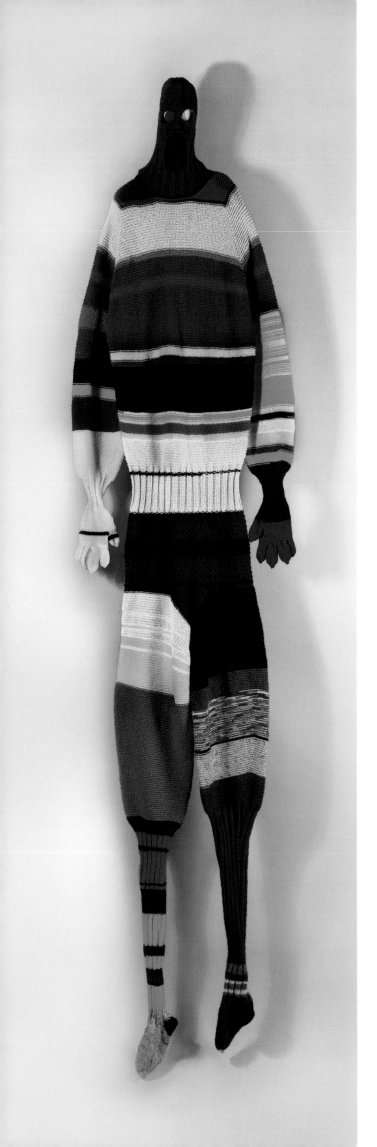

The only protection that Newport's homey suits realistically offer is from the cold. They therefore underscore the falsehood of the security promised by fantastic beings. While some of Newport's first costumes reflect the outfits of specific superheroes, he altered them in some way; for example, they are far from skin-tight. Instead they droop and sag, and when displayed on a hanger they are lifeless, shroudlike vestments that seem to mock their own implied physical power. But their misshapenness also indicates they were not custom-made and will fit no one well, but anyone adequately. They are everyman's costume and will look equally ridiculous no matter what the shape or size of the wearer.

Every-Any-No Man (2005), a costume for a character invented by Newport, takes the concept to the extreme because it is ten feet tall, rather than the human-size, six-feet height of Newport's other costumes. Its exaggeration is comic rather than intimidating and best emphasizes the implausibility of superheroics and the futility of aspiring to them. It was made

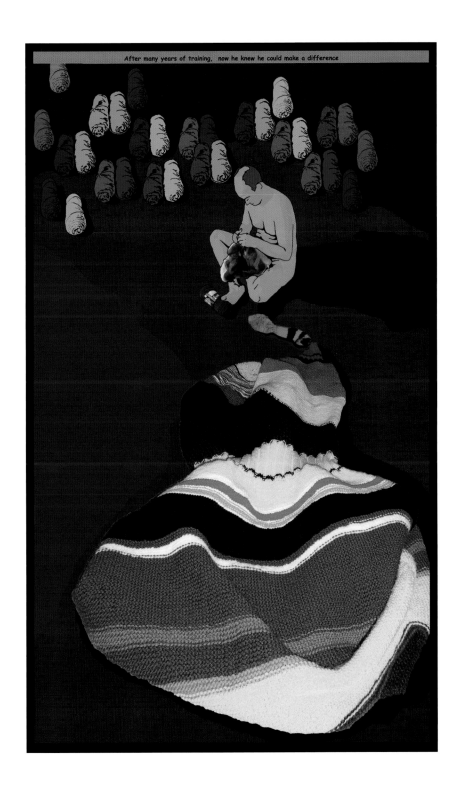

Every-Any-No Man, 2005,
acrylic yarn and buttons,
120 x 26 x 6 in.
Courtesy of the
Greg Kucera Gallery

Training, 2005,
photo inkjet print
on paper, 19 x 13 in.
Courtesy of the
Greg Kucera Gallery

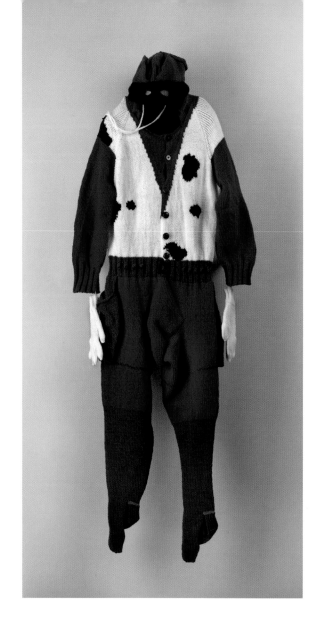 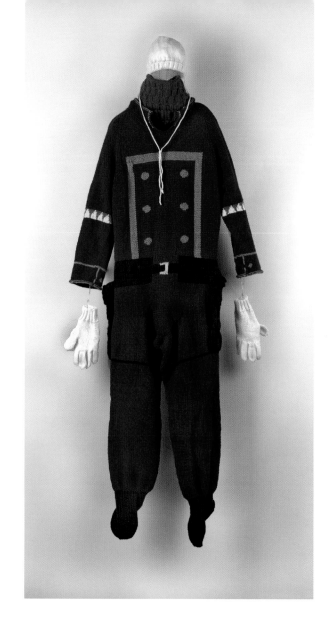

from the yarn remaining from other costumes that Newport had created up to that point: the orange of *Aquaman*; the gray of *Batman*; the red, white, and blue of *Patriot Man*, for example. *Every-Any-No Man*, an impotent compilation of castoffs, begs the question, If the superhero hand knits his own suits, does that act diminish his power?

Two other costumes in this exhibition, *Raw Hide Kid* (2004) and *Two Gun Kid* (2006), are stereotypes derived from comic book characters and speak to the invented romance and heroics of the American Wild West as depicted in cinema and storybooks. *Raw Hide Kid*, for example, has holsters and spurs but no gun because, according to the artist, "guns

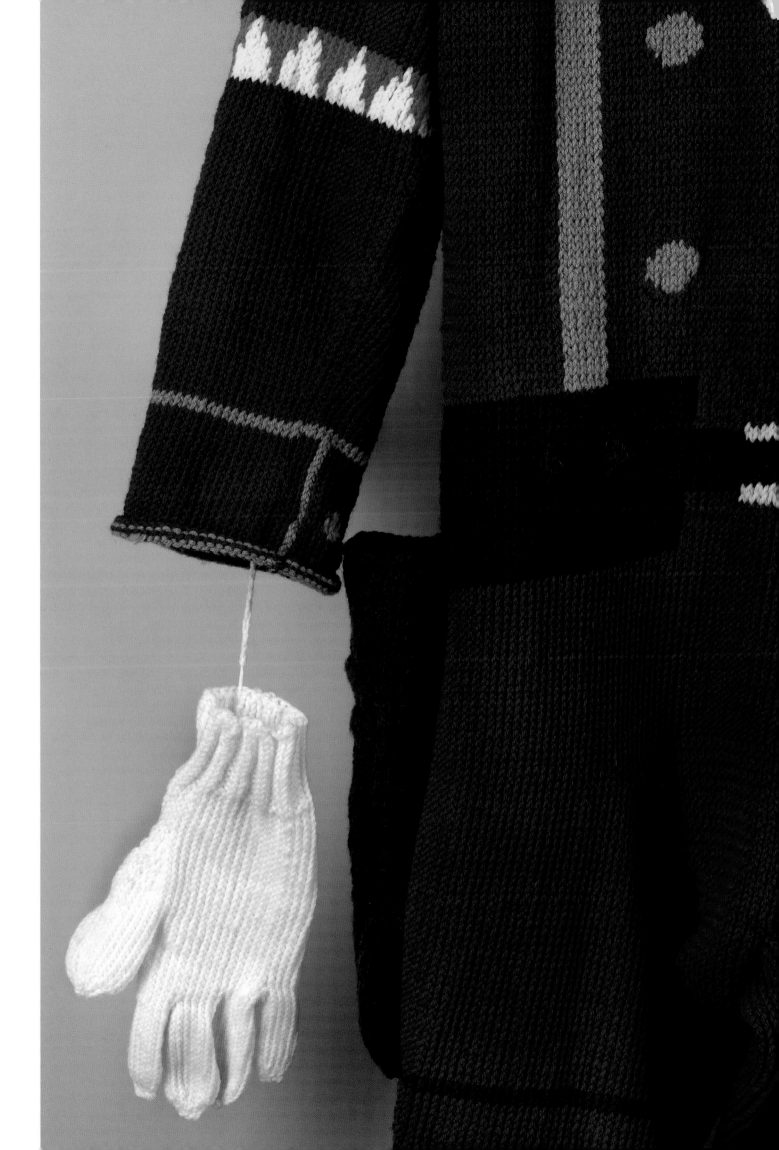

are tools not costume."[17] Undercutting the tough-guy image, the gloves are attached to each other with a long piece of yarn that drapes around the neck, like the mittens children wear. Recently Newport has focused on performance (actual, imagined, and planned) and its documentation in prints and video. All of these works depict the artist creating and/or wearing one of his costumes. In *The Scout* (a work not included in the Renwick exhibition), one of three photographs documenting his performances, the artist is pictured wearing his *Raw Hide Kid* costume while seated on a docile horse. Newport and the horse have their backs to the viewer and stare out at the desert landscape. The composition of the photograph is based on that of a painting by Frederic Remington in the collection of the Sterling and Francine Clark Art Institute, in Williamstown, Massachusetts, a place that Newport visited often while he was growing up. With this performance Newport spoofs both the imagined heroes of the American Western and high art.

Sweaterman 3 (2005), part of Newport's invented series of heroes known as "Sweatermen," is the character Newport adopts in the video *Heroic Efforts* (2007; see p. 42). For this piece of theater, Newport sits in a rocking chair in an empty corner of a vanilla-colored room wearing the ivory-colored *Sweaterman 3*. Here he knits with bright red yarn on circular needles, rocking to the pulse of the *William Tell* overture, the theme music for the 1949 to 1957 television series *The Lone Ranger*, once again supporting Newport's commitment to the populist, theatrical medium of TV.

◁ **TOP**
Button Up, 2005,
photo inkjet print
on paper, 13 x 19 in.
Courtesy of the
Greg Kucera Gallery

◁ **BOTTOM**
Wardrobe, 2005,
photo inkjet print
on paper, 13 x 19 in.
Courtesy of the
Greg Kucera Gallery

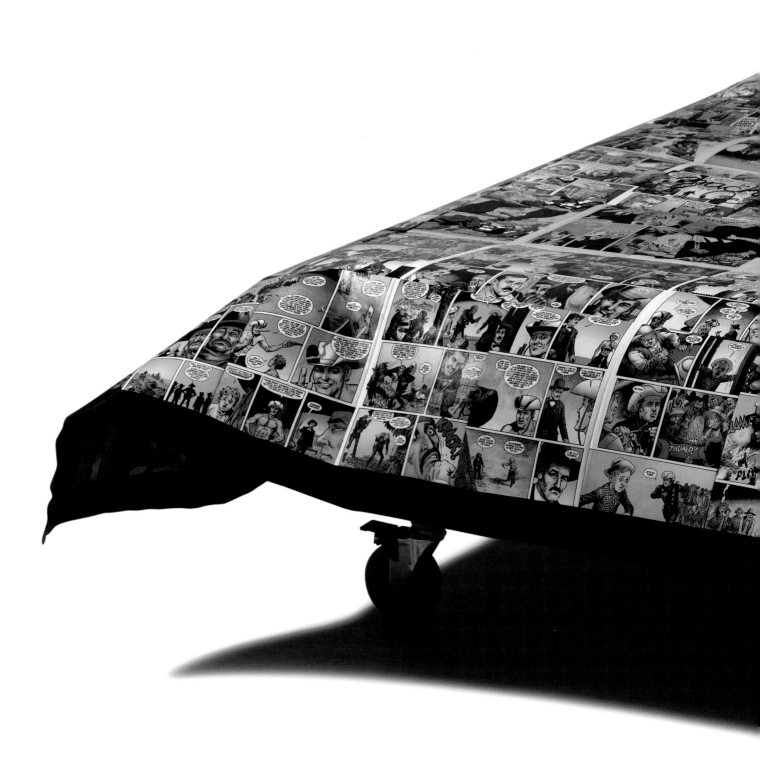

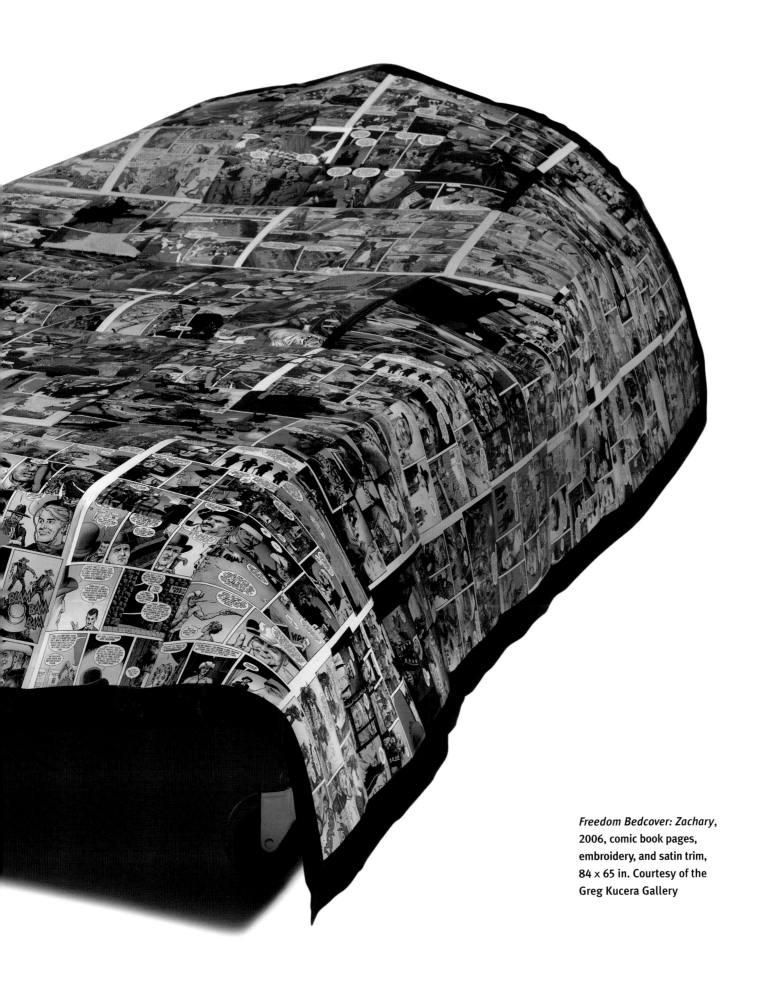

Freedom Bedcover: Zachary,
2006, comic book pages,
embroidery, and satin trim,
84 x 65 in. Courtesy of the
Greg Kucera Gallery

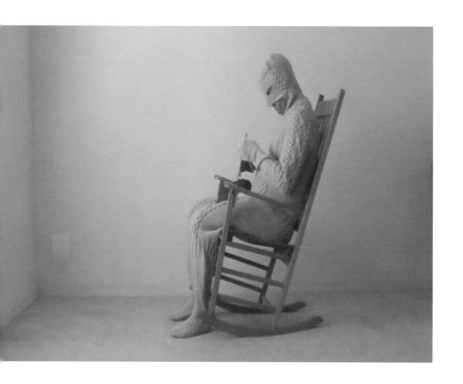

**Still from *Heroic Efforts*,
2007, DVD,
3 minutes, 19 seconds,
Courtesy of the
Greg Kucera Gallery**

In the print *Knitting a Forcefield I* (2005), a naked Newport sits on the floor among a gathering of what appear to be uniformed men. Only the torsos and legs of these men are depicted, and they seem flat relative to Newport, who is rendered more three-dimensionally. This spatial disjuncture distinguishes the "real" from the "fantastic," and Newport is depicted as knitting furiously, as if that act will protect him from impending harm. *Freedom Bedcover: Zachary* (2006), created from comic book pages that Newport embroidered then stitched together into a blanket, also feigns protection. It draws parallels between today, when international political struggles are primarily instigated by a single superpower, and the cold war, which marked the advent of television. Today, like the cold-war era, the domestic is our only zone of security and comfort, and that sense of security is perceived rather than actual, a fantasy reinforced through television and home entertainment.

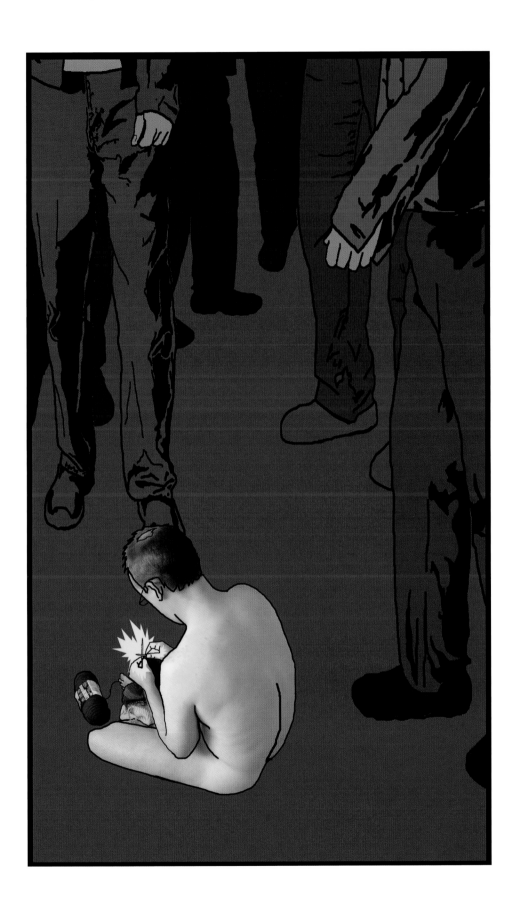

Knitting a Forcefield I, 2005,
photo inkjet print on paper,
19 × 13 in. Courtesy of the
Greg Kucera Gallery

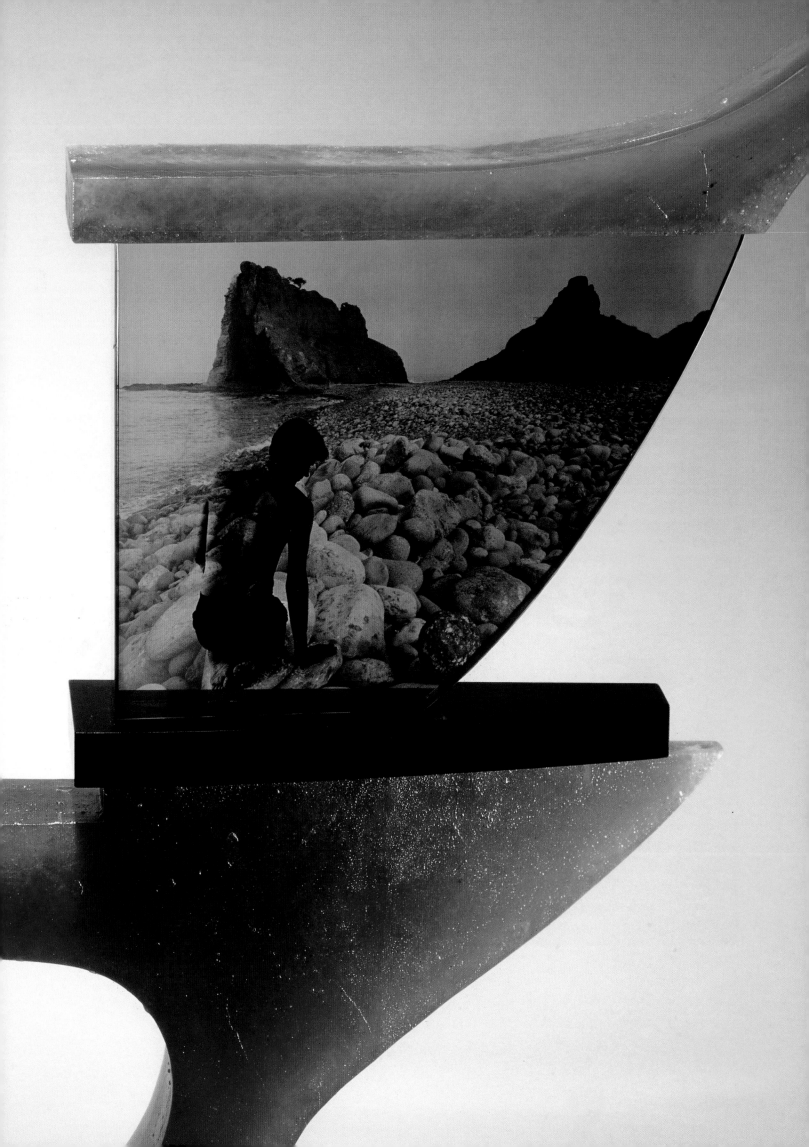

mary van cline

Mary Van Cline creates large black-and-white photographs of austere landscapes and combines them with glass to create staged environments. She portrays, for example, steel skies that dominate gray waters of a rocky coastline, a once flowing river shrunken into a small pool, gnarled pines and pinnacles of rock that define the quintessential desert terrain. Placed within these landscapes are posed, idealized figures, frozen in time and in youth, often cloaked or draped, oversized and lording over nature, possibly a homage to Greek humanism, which places human beings at the center of social and moral concerns. Van Cline's source material ranges from classical Greek statuary to Noh theater—a classical, stylized form of Japanese musical drama so slow moving that the actors seem to pause in time. Likewise, all of Van Cline's images evoke an enduring stillness. She bridges West and East and makes the realistic (associated with photography) seem fantastic (associated with surreal shifts in scale and masked subjects). Van Cline's works ask the audience to immerse itself in a theatrical arena.[18]

Van Cline traveled and photographed the length of the Japanese

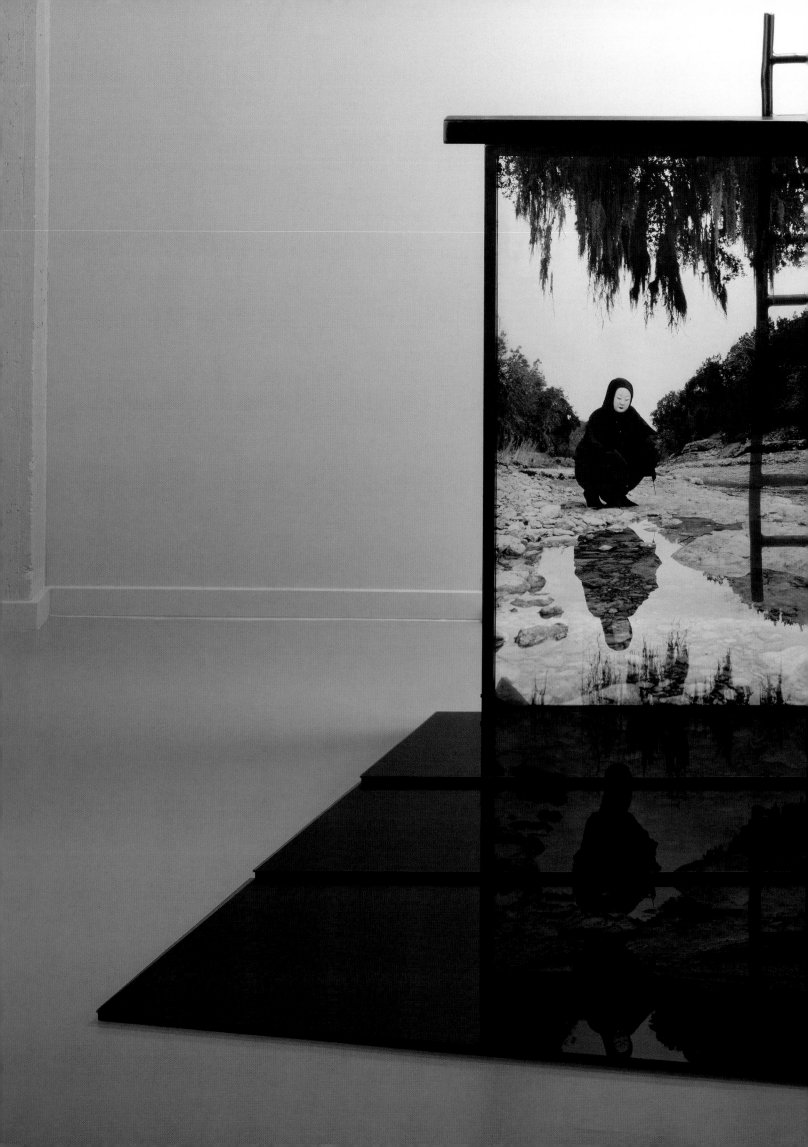

◁◁
The Ocean of Memory Within
(detail), 2008. See p. 54.

The Listening Point, 1993
photosensitive glass, wood,
and metal, 72 x 108 x 96 in.
Courtesy of Leo Kaplan
Modern

47

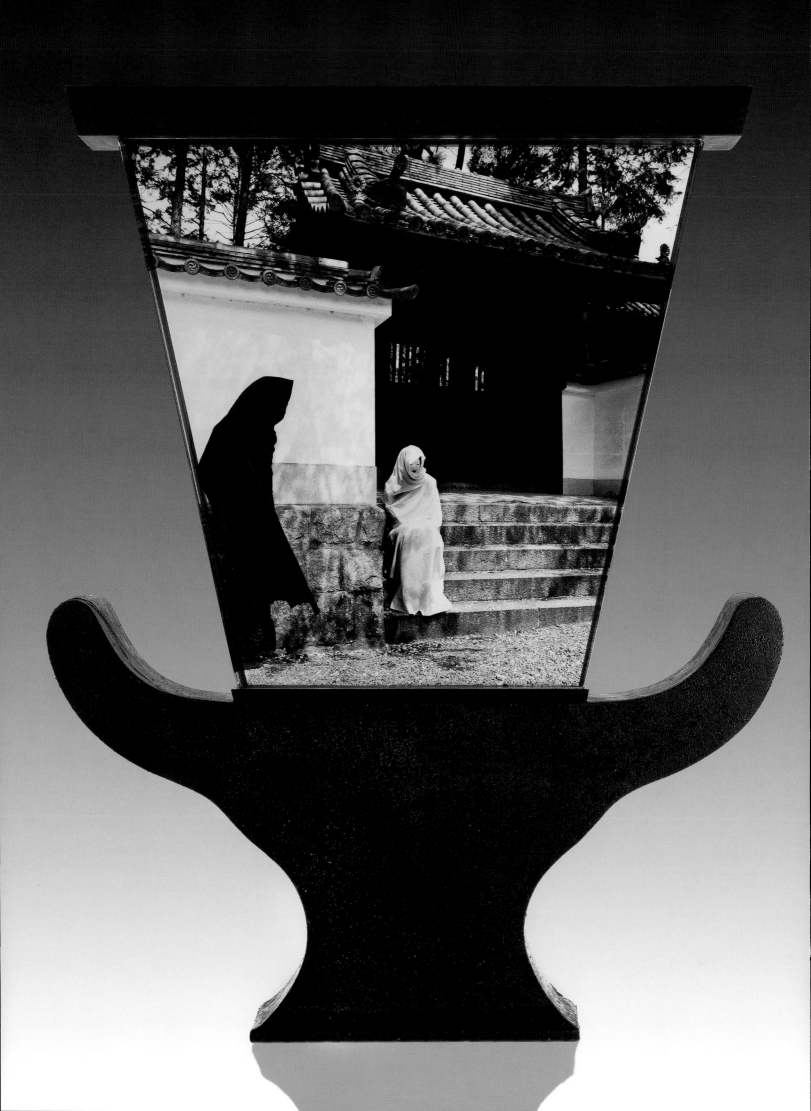

archipelago in the late 1980s. Images created there anchor two works from the 1990s, both titled *The Listening Point.* The larger version (1993) features a photograph of a figure draped and hooded in black squatting in a dry riverbed and wearing a white Japanese Noh mask meant for a female character. Noh actors are usually male, and typically only the main actor wears a mask, which is intended to portray a female or nonhuman (divine, demonic, or animal) character. In Van Cline's images the character contemplates its own gender-shifted transformation in a small puddle.[19] The pale mask lends him a ghostly presence and brings to mind the characters from Akira Kurosawa's 1950 black-and-white film classic *Rashomon,* a nonlinear and moody narrative wherein each character tells a different version of the same murder story.[20]

The subjective nature of reality is one theme of *The Listening Point* because a glossy, black glass proscenium—a direct reference to staging—mirrors the photographed figure and also mirrors the sculpture's surrounding space. Therefore, the actual world and the one portrayed in Van Cline's photo overlap. In addition, the photograph stands perpendicular to the floor and when lit it behaves like an old-fashioned 35-mm transparency, casting images on the floor and wall behind it, in effect increasing the space that the art work occupies. *The Listening Point* incorporates the viewer, who enters its realm and becomes part of its fantasy. Assumptions about what is actual and what is represented come into question; reality and fantasy unite.

The hooded black figure that appears in *The Listening Point* also

◁
***The Listening Point*, 1999,
photosensitive glass
and pâte de verre,
25 ½ x 20 ¼ x 4 in.
Smithsonian American Art
Museum, Gift of the James
Renwick Alliance**

appears in a smaller work of the same title (1999), which is cast in glass and resembles a vessel form. Here he enters the scene from the left and approaches but does not acknowledge a second figure cloaked in white who is seated on the steps of what appears to be a temple. Though their scale and visual functions are different, the two pieces evoke similar ideas—such as ritual, solitude, psychological reflection, and catharsis. Many of Van Cline's titles, which rely on words such as "time," "cycles," "passage," "listening," and "memory," underscore these themes. In addition, Van Cline acknowledges a deep interest in the balancing effects of the "five elements," or *wu xing* in Chinese.[21] First mentioned in the Daoist classic *Book of History,* the elements are water, fire, wood, metal, and soil, most of which Van Cline represents in her work and uses to create it. *Wu xing* can also be translated as "five phases" representing dynamic concepts that define the evolutionary cycle, the rhythms of life, and the relationship among those phases, with one phase or element promoting or restraining another to achieve a sense of balance.[22]

Although Van Cline remains committed to the study and representation of Asia, imagery referring to the ancient world of the Greeks and Romans also appears. For example, *Cycles of Relationship of Time* (2000), which consists of components of cast glass assembled into a silhouette of a vessel, is topped by a form that references a Japanese torii gate, an architectural structure that identifies the entrance to a sacred place. The center of *Cycles of Relationship of Time* is pierced by a portal that indicates an entry point into the unknown.[23] An image of an ocean

▷
Cycles of Relationship of Time, **2000 photosensitive glass, pâte de verre, and bronze patina, 25 x 26 x 6 in. Private collection**

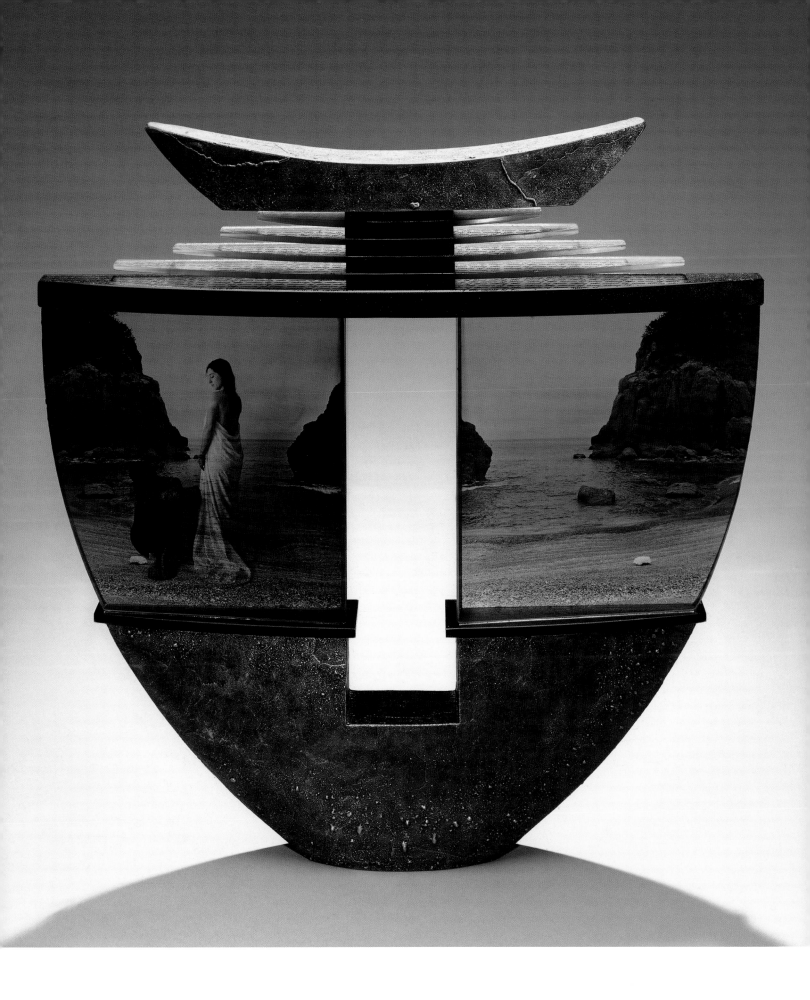

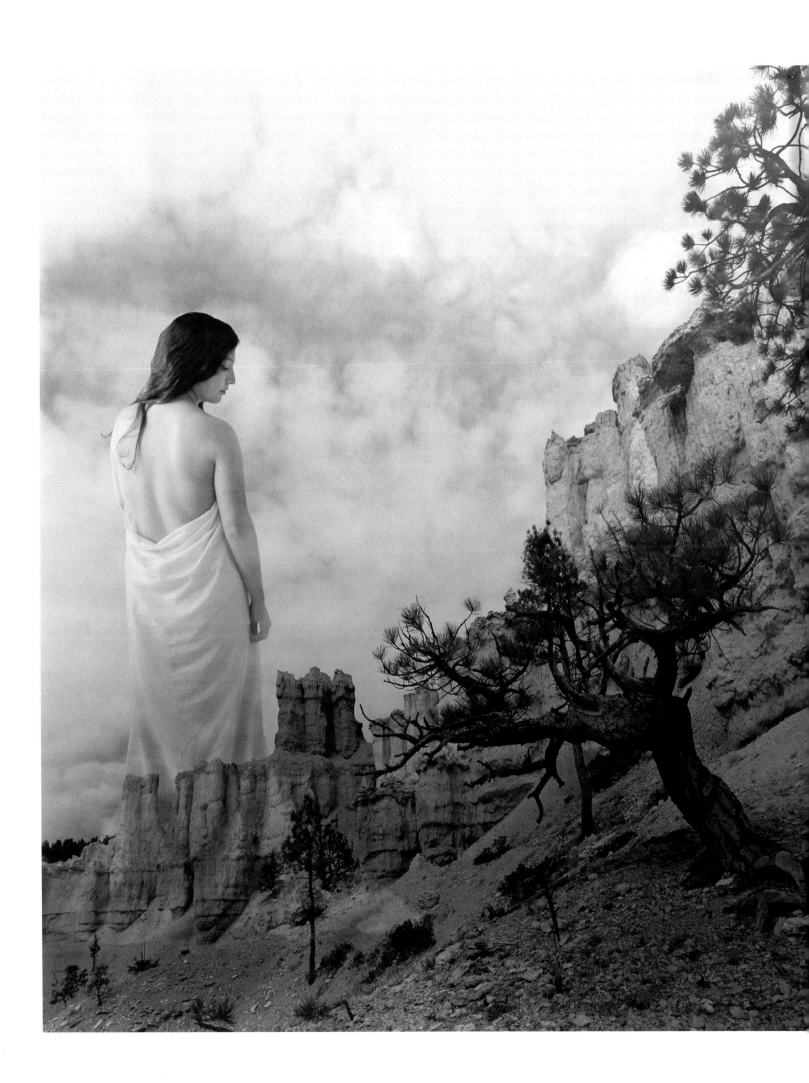

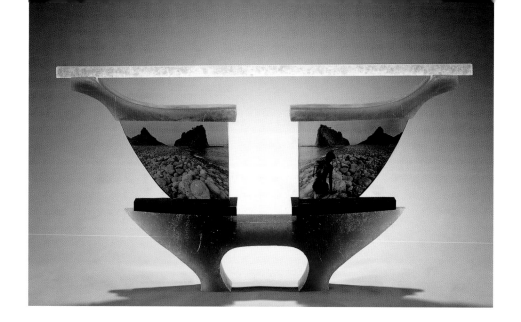

Healing Passage of Time,
2008, photosensitive glass,
two panels, each 72 x 60 x 4 in.
Collection of the artist

The Ocean of Memory Within,
2008, photosensitive glass
and pâte de verre,
30 x 60 x 6 in.
Ms. Patricia Schaefer
and Mrs. Tove Stimson

cove is placed on either side of this doorway, connoting the symmetry and balance of *wu xing*. In the left-hand image, the figure of a young woman stands erect with her back toward the camera. Draped in white fabric, she looks down on a male figure seated in a fetal position, a pose that symbolizes life before birth. The woman looms large in comparison to the landscape and is apparitional, offering death as a counterpoint to the male's nascent life and lending a surreal quality to the scene. Her scale opposes that of an important genre of East Asian landscape painting tradition, where awe-inspiring mountains dwarf human figures to indicate the power and mystery of nature, and instead is anchored in Western thought and humanism. In the group of sculptures included in *Staged Stories,* Van Cline conflates these two broad systems of belief.

Van Cline continues the theme of time in her newest work *The Ocean of Memory Within* (2008), which has a structure similar to *Cycles of Relationship of Time*: both convey an image of an ocean landscape with a rocky beach mirrored on each side of a portal. For both of these works the artist coated glass with photosensitive emulsion and then exposed the images in a darkroom under an enlarger, thus alluding to the origins of photography and the use of glass plate negatives. *Healing Passage of Time* (2008) has a similar aesthetic and concept, but employs

modern processes and technology. This image was created using a Hasselblad medium-format film camera. The film was scanned and printed onto transparent media, and finally sandwiched between two pieces of safety glass. Because she uses both film and digital processes, Van Cline's methods of creation, like her imagery, link the past with the present, also a function of historical theater and storytelling.

One of Van Cline's most recent projects involves the evocation of the four seasons, another important theme in Asian art. *Winter Ice Branches* (2008) is part of this series. These stacked, oversized, transparent glass leaves, simultaneously fragile and monumental, connote the chilly isolation of winter, the season that represents the end of the annual cycle. Within each of her sculptures Van Cline emphasizes the themes of her life's work: that beginnings bring endings and then cycle back on themselves. She harnesses the three unities of Greek drama (time, place, and action) to represent a pivotal moment. The artist incorporates photographs into objects, some of which create participatory environments. She encourages her audience to enter an imagined place carved out of an actual one, unifying fantasy and reality.

Winter Ice Branches, 2008,
ivory pâte de verre,
each branch 24 x 11 x 90 in.
Collection of the artist

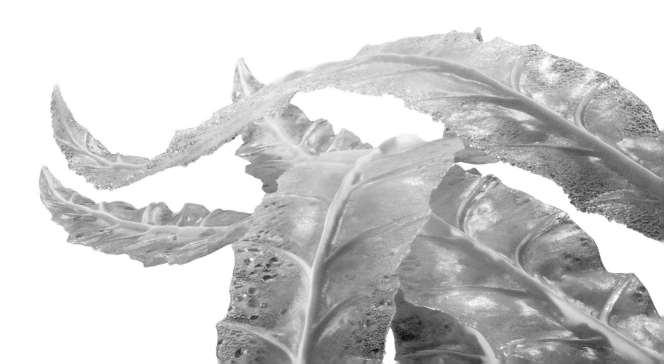

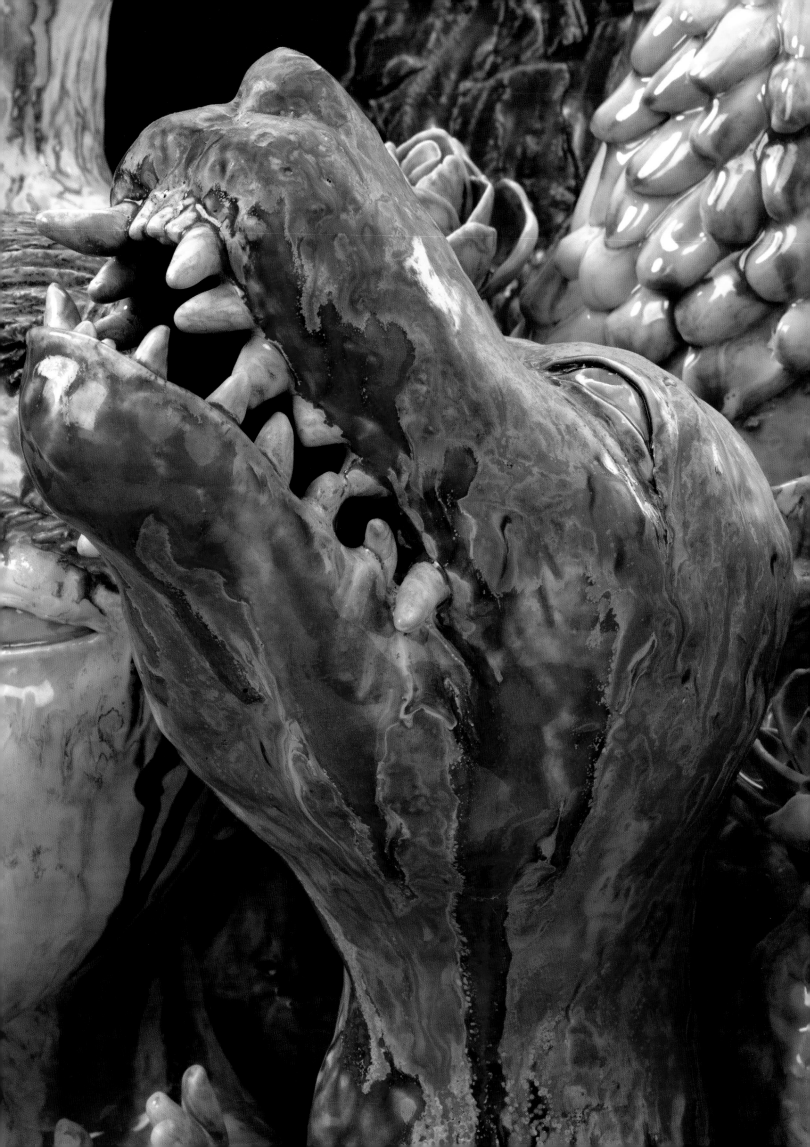

sunkoo yuh

The ceramic sculpture of SunKoo Yuh, who was born in South Korea and immigrated to the United States in 1988, is composed of tight groupings of various forms, including plants, animals, fish, and human figures. While Korean art and Buddhist and Confucian beliefs inform some aspects of his imagery, his work is largely driven by implied narratives that often suggest sociopolitical critiques. Yuh's juxtaposition of comedy and tragedy alludes to theater of the absurd. So does his unlikely mix of characters caught in impossibly expansive plots. This type of performance, also known as antitheater, developed in Europe in the late 1940s in part as a response to World War II. Time, place, and identity break down; dialogue may be nonsensical; and the narrative is open-ended—sometimes hopeful, sometimes nightmarish. Theater of the absurd was born during the same

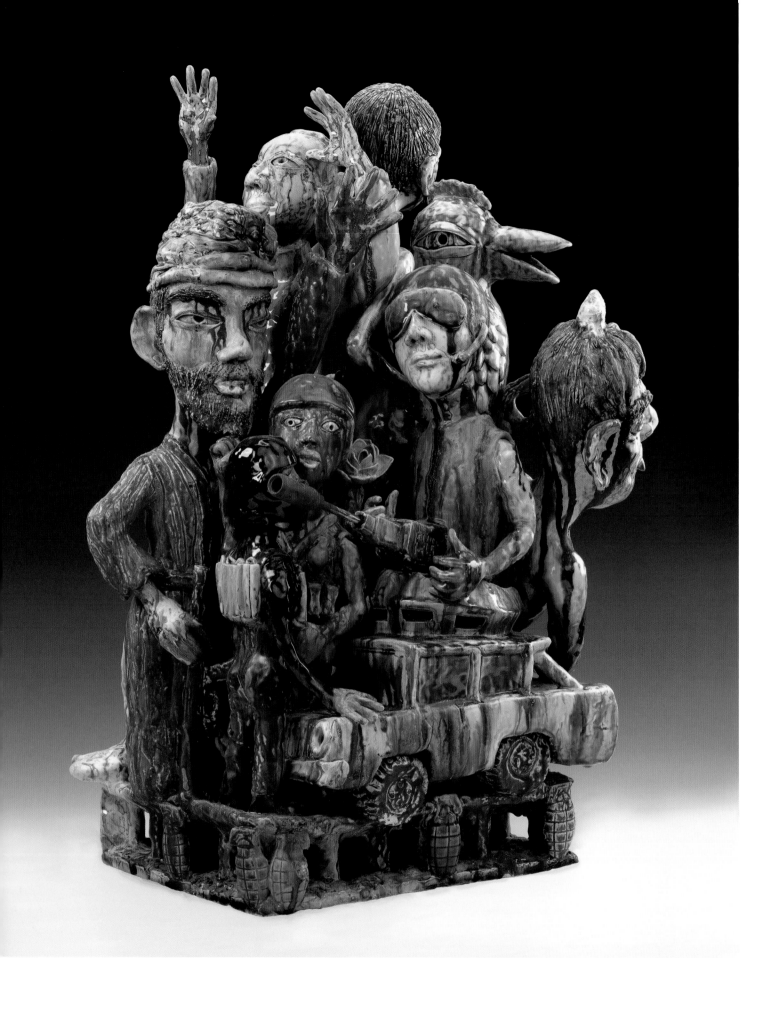

period that spawned German expressionists such as Max Beckmann. Yuh acknowledges the influence of Beckmann's paintings and the contemporary ceramic sculpture of Steven De Staebler and Jean-Pierre LaRocque.[24] All of them elongate shapes and infuse them with a sense either of anxiety, in the case of Beckmann, or of weathered endurance, in the case of De Staebler and LaRocque. Yuh's works have all of these qualities.

In *False Start* (2006) Yuh employs the tools of theater of the absurd to respond to a more recent war, that in Iraq. The sculpture includes a representation of a soldier who wears helmet and goggles and holds a machine gun. He is surrounded by various figures, including an oversized bird that looks like a crow, a character from Yuh's imagination that he associates with mischief. Also present is a wide-faced figure with beard and turban; the largest in the group, he smiles and, at first glance, seems to add levity to the scene. However, there is little humor here, for below him is another figure, about half his size and draped in black from head to toe, a woman in a burqa who has explosives strapped to her chest. The overall scene is one of tension and surreality, something emphasized by the dramatic and unexpected shifts in scale of the figures, a trademark of Yuh's work that recalls that of ceramist Viola

◁◁
One More Chance (detail), 2006. See p. 69.

◁
False Start, 2006, glazed porcelain, 31 x 22 x 18 in. Collection of the artist

False Start (detail), 2006

Frey (1934–2004), who created human figures, gigantic and Lilliputian, beginning in the 1970s. Yuh's interest in German expressionist painting is evident in the elongation of many of his figures, his unsettling spatial configurations that stem from the density of his figural groupings, and the acrid colors and fluidity of his glazes that give his figures a forlorn, even desperate feel. There is a postapocalyptic sensibility to his sculptures, especially works like *False Start* and *Memory of Pikesville, TN* (2003). That sense is communicated by Yuh's glaze technique, based on that of Chinese Tang Dynasty funerary sculptures, which Yuh admires.

All of the characters in *False Start* rest on a ceramic base about four inches high, which comprises two horizontal clay slabs decorated with hand grenades. Recently Yuh designed the bases for his sculptures to be more architectural in form and, in particular, more stagelike. The base for *False Start* is an example. *Long Beach Summer* (2004, a sculpture not included in the exhibition)—a monumental column weighing more than 1,000 pounds—is often exhibited on a wood pallet, which allows for forklift transport. The pallet's structure inspired Yuh's double-slab bases. The work's compressed figures convey angst, but they also support each other, emphasizing Yuh's belief in collective achievement. This outlook allies him with playwrights associated with theater of the absurd, who, like Yuh, explored the full spectrum of life, claiming a "bewilderment and wonder at the inexplicable universe."[25]

▷

Memory of Pikesville, TN,
2003, glazed porcelain,
34 x 29 x 26 in.
Collection of the artist

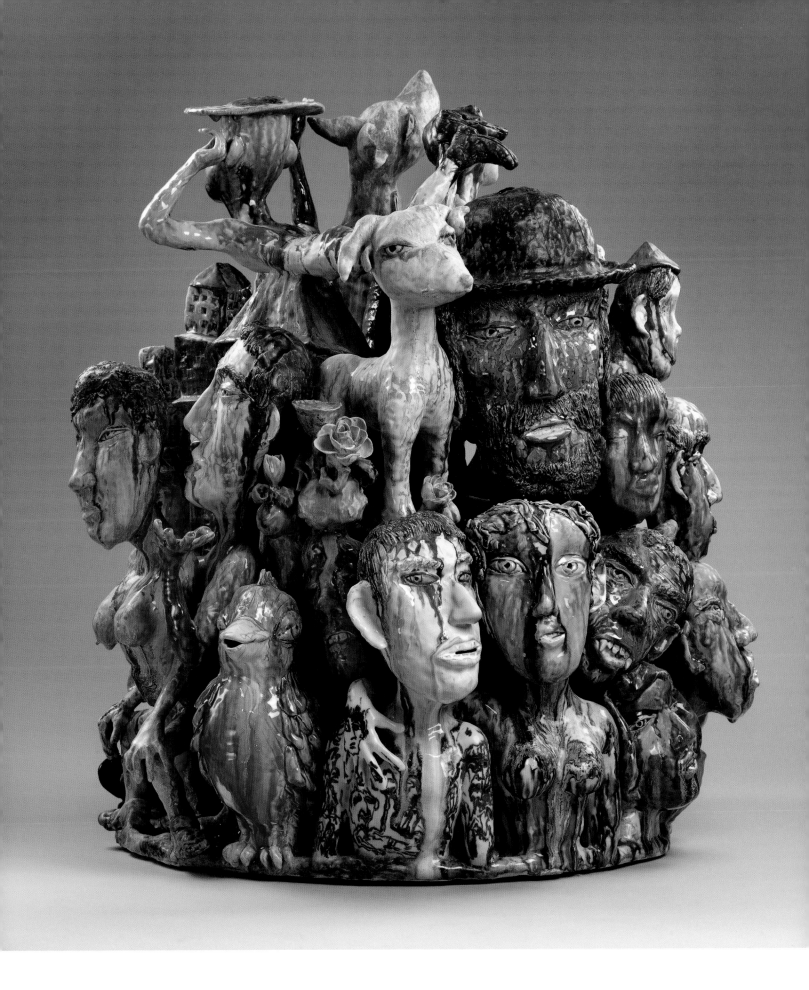

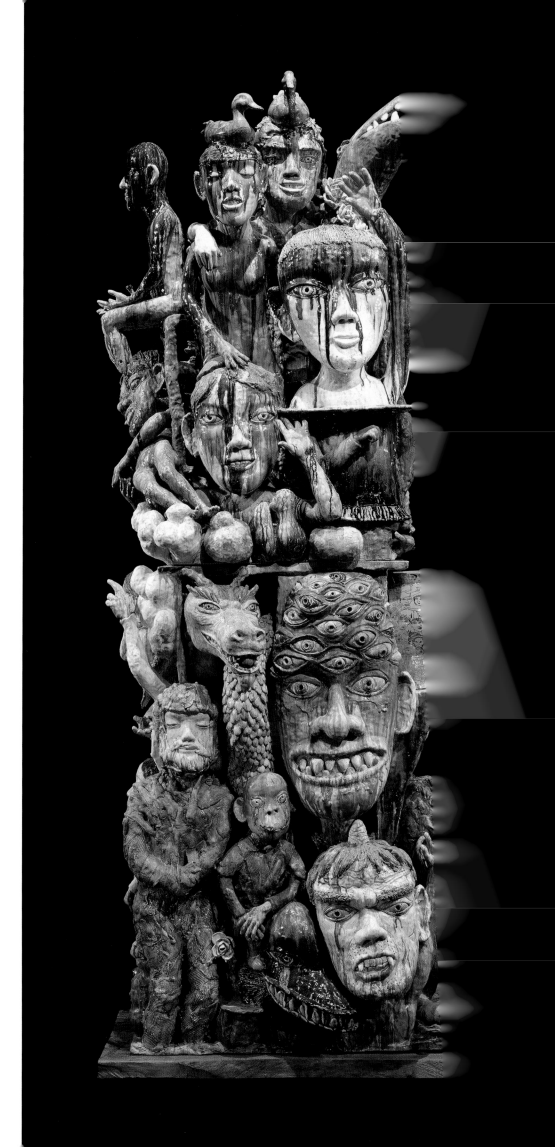

Long Beach Summer, 2004,
glazed porcelain,
149 x 56 x 38 in.
Collection of the artist

▷
Long Beach Summer
(detail), 2004

Korean Yi Dynasty folk painting, a genre that bursts with graphic and colorful renditions of plants and animals, also influences Yuh. For example, in Yuh's *Family Union* (2007, a sculpture not included in the exhibition), a crowned figure mimics one that appears in Max Beckmann's painting *The Actors* (1941–42), while the serpent with the human head is a hybrid creature derived from Korean art. Beckmann considered self-portraiture a major genre and often depicted himself in a variety of guises: king, Homeric hero, Harlequin, Christ.[26] Many of his paintings portray stage sets in which figures enact dramatic parts. Yuh's interest in adopting an ever-shifting identity parallels Beckmann's. All of the characters in Yuh's sculptures are, in part, self-portraits, testaments to the multiple roles and personae a single person can assume, especially an émigré with one foot in the culture of his place of birth, another in that of his chosen home.

Yuh credits Confucianism as his "philosophical pillar." It emphasizes a reverence for one's teachers, as does Yuh, who often

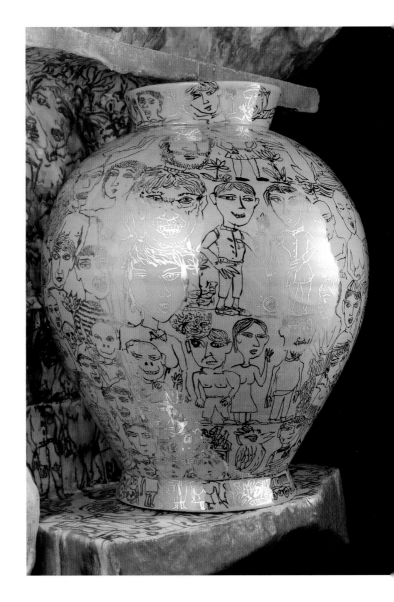

speaks of his, Tony Marsh and Wayne Higby. But Confucian art adopts a monochrome palette meant to appeal to the intelligentsia and upper classes. Though Yuh predicts that he may find the "courage to work monochromatically someday," for now the dynamic color and forms of folk art, associated with the lower social strata in Korea, are his aesthetic muses.

Yuh's drawings, however, are another matter. They are brushed in an exuberant and gestural style in black ink on *hanji*, a paper made from mulberry-tree bark. Yuh learned to draw when he was young and passed a rigorous technical exam to gain entrance to art school in Korea, where he drew from copies of Greek sculptures. It took him years to grow beyond this academic mode of expression. He credits his time as a graduate student at Alfred University in New York as the turning point for his looser mode of drawing, which he feels is "more pleasurable" to himself and the viewer. Yuh prefers several drawings to be presented as a single unit, and the compilation of twenty of them into an Asian-style screen (as seen in *Staged Stories*) refers to the historical use of Korean folk paintings as room dividers.

His drawings help generate ideas for his sculptures. An example of this process is the drawing *Just You and Me* (2007), which has a counterpart in a sculpture of the same title. In this drawing a single horn sprouts from the top of the head of a nude male figure, a self-portrait that recurs in many of Yuh's works. This figure caresses the breast of a nude female whose hair is bound up in a pair of topknots. The fact that

▷ **TOP**
Wiseman's Tear, **2008,
ink on** *hanji* **(Korean paper),
25 ½ x 38 ½ in.
Collection of the artist**

▷ **BOTTOM**
From a Distance, **2008,
ink on** *hanji* **(Korean paper),
25 ½ x 37 ½ in.
Collection of the artist**

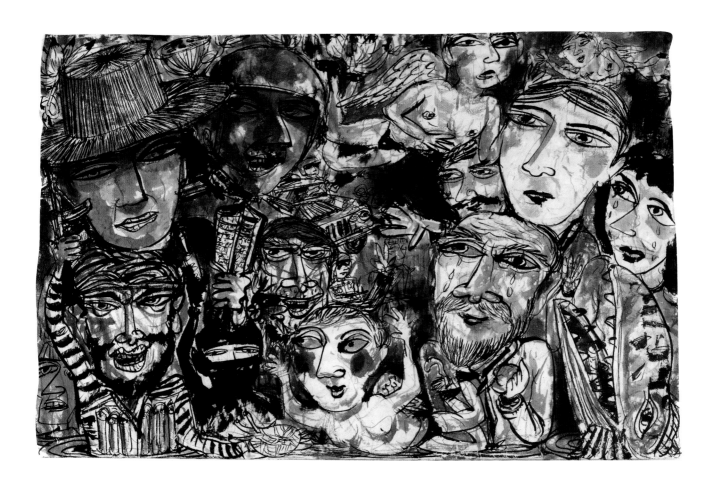

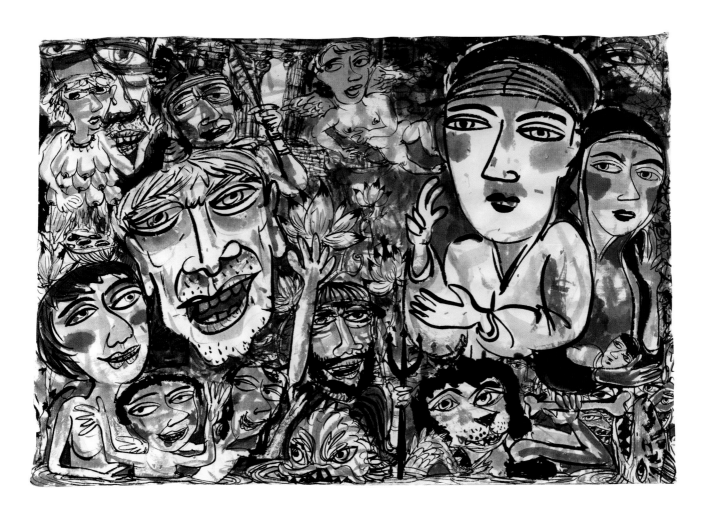

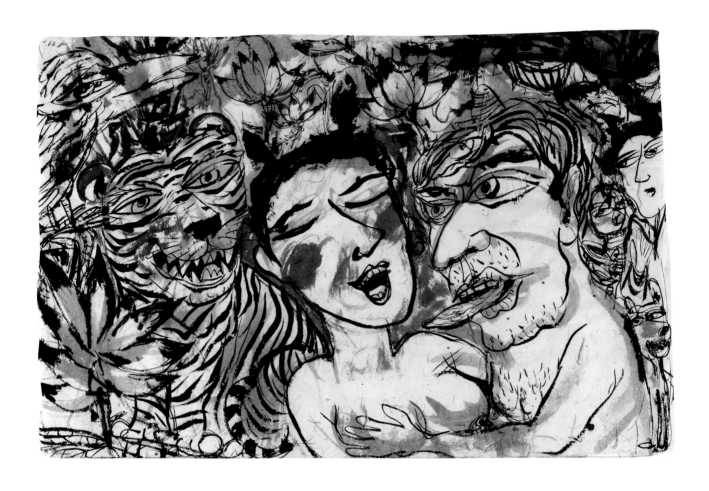

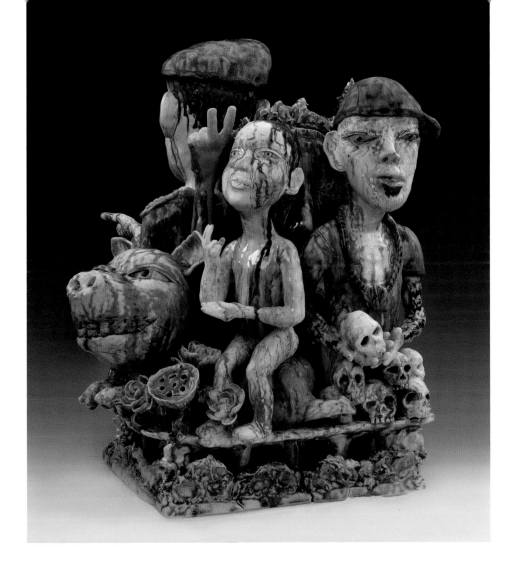

the drawing portrays a tiger while the sculpture portrays a pig is not an important difference for Yuh, because the main focus in both is the tender and playful relationship between the two figures.

The drawing *Need Sacrifice* (2007), which has not yet been interpreted in sculptural form, portrays a bearded figure as the central character. He is guarded by a turbaned man wielding a knife (but waving cheerily at the viewer) and flanked by two bikini-clad women, one drinking a martini, in what Yuh calls a "scary party," an oxymoron that connects Yuh's work to antitheater. The artist again shows us the unnerving rift between the appearance of camaraderie and the true intention of deceit and violence. *Need Sacrifice* is based on the Taliban capture of twenty-three South Korean Christians in 2007. Most of these

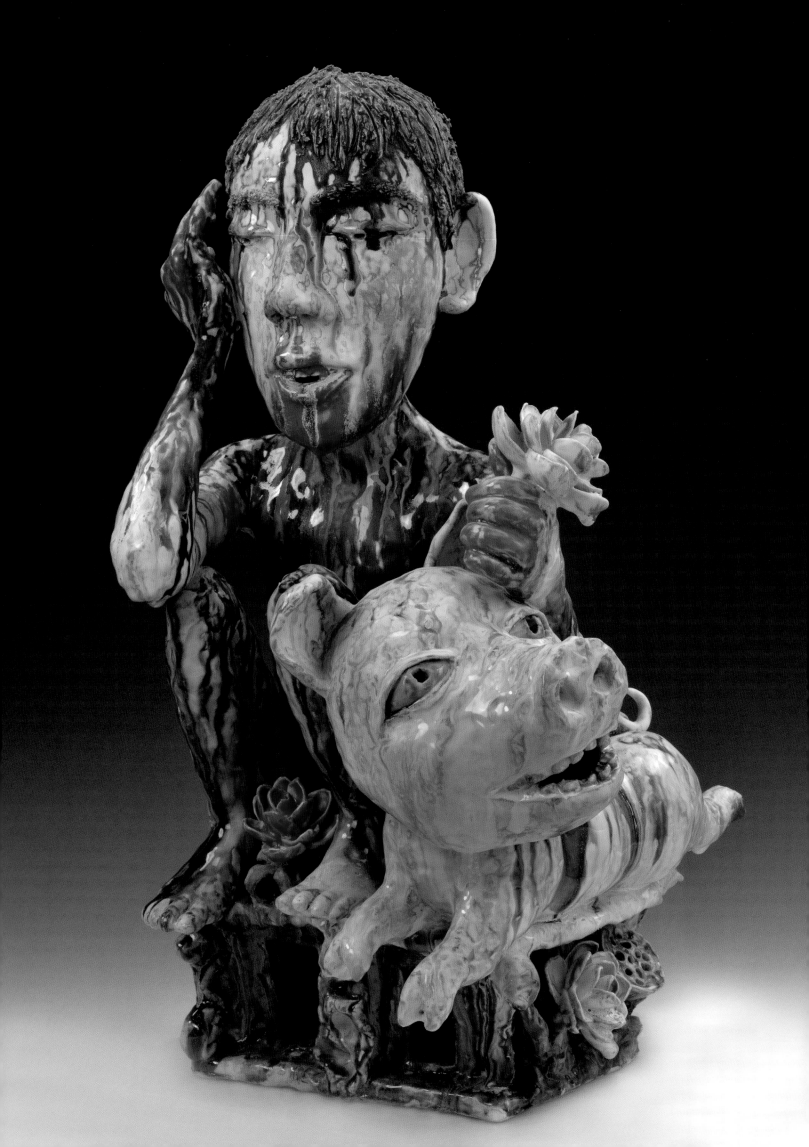

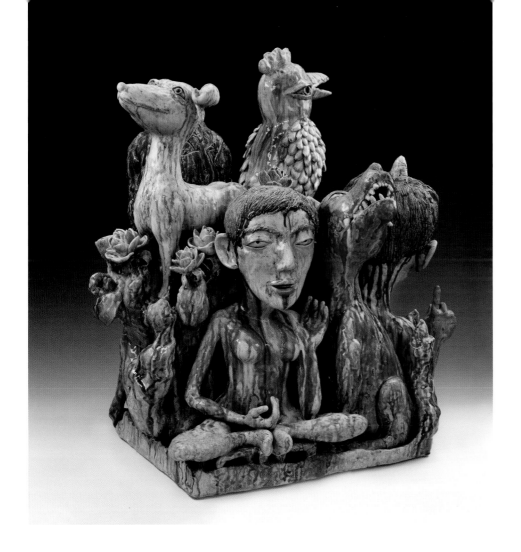

◁
Fortune Pig, 2007,
glazed porcelain,
25 x 16 x 15 in.
Collection of the artist

One More Chance, 2006,
glazed porcelain,
29 x 28 x 24 in.
Collection of the artist

humanitarian workers were held hostage and released after six weeks;
however, two were killed. Thirty percent of South Koreans are Christian, as
is Yuh. However, Confucianism and Buddhism are also strong influences
in South Korea and, not surprisingly, there is evidence of all three belief
systems in Yuh's life and his work.

Yuh frequently draws and sculpts animals from the Chinese lunar
calendar. The animal of a given year often takes center stage in works
he creates during that period, marking time and change. The sculptures
Fortune Pig (2007) and *Year of the Pig* (2007, a sculpture not included in
the exhibition) are examples. *Year of the Pig* has four portrait busts that
look toward each of the four cardinal points. On top of their heads
is a pile of pigs. Surrounding the base are clay reliefs of angelic putti,
superheroes, and comic faces with wide-set eyes and oversized ears

similar to those drawn by children—a compression of the elements from both high and low culture that Yuh shares with Christyl Boger. Yuh hand builds most of his figures, but here secondary elements, including the pigs, are cast. However, the overall sensibility is a far cry from the repetition that multiple cast forms usually convey due to the flowing, dripping glazes that Yuh uses. He brushes, splashes, and drips as many as forty layers of glaze onto his bisqued clay sculptures. Each piece is fired twice, once before and once after the glazes are applied. Yuh creates these modest-scale sculptures in porcelain because its stark white color enhances the vibrancy of his colorful glazes. As with most ceramics, there is a degree of uncertainty about the outcome of the kiln-firing process that Yuh embraces. To him, these uncontrollable aspects, such as shrinkage of form and interaction of color and glazes, are metaphors for the uncontrollable aspects of life, another connection to theater of the absurd. Yuh tries to negotiate them with grace, citing as his model his sister's calm acceptance of a potentially terminal illness.

In recent years, Yuh's working methods have become more evenly paced. When he was younger he would work frantically for hours on end to meet a deadline, leaving little time to spare; this process necessitated intuitive methods of creating. Today periods of production are more regular and controlled, and his decisions are, therefore, more considered and intellectual. As a result, day-to-day experience, its beauty and its horror, informs the content of Yuh's art.

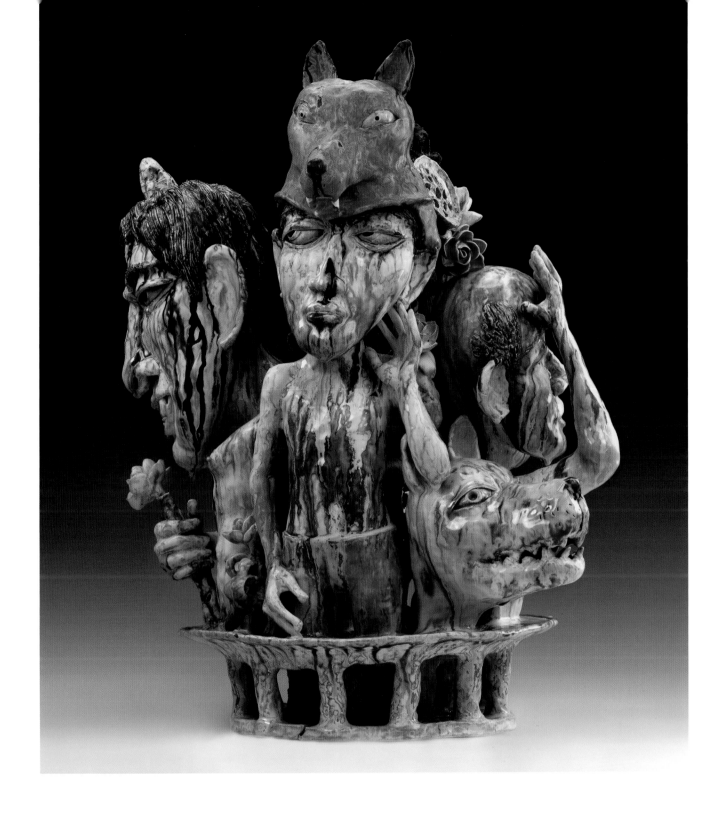

He lends to these mundane interactions the qualities of antitheater by conveying the inexplicable quality of the human experience. His figures, piled together on stagelike bases, urge us to communicate across cultures and to focus on the good.

Can You Hear Me?, 2007,
glazed porcelain,
27 x 22 x 17 in.
Collection of the artist

artists' biographies

christyl boger

Born in 1959 in El Paso, Texas, Christyl Boger went to graduate school after receiving a B.F.A. from Miami University in Oxford, Ohio, where she studied painting with a focus on the figure. After graduating, she attended ceramics classes at Michigan State University, developing a portfolio that enabled her to study at Ohio University in Athens.

After receiving her M.F.A. in 2000 Boger completed a one-year residency at the Clay Studio in Philadelphia, where she was the Evelyn Shapiro Fellow. During her year there she developed a body of work titled *The Chymical Object* that, in her words, drew "an equation between the figure and the decorative ceramic object to create a metaphorical representation of a human subject shaped by its cultural heritage." In 2003, she was named an Emerging Artist by the National Council on Education for the Ceramic Arts. She has been an artist-in-residence at the Archie Bray Foundation in Helena, Montana, and the International Ceramic Research Center in Denmark.

Boger is an assistant professor of ceramics at the Henry Radford Hope School of Fine Arts at Indiana University in Bloomington. She teaches workshops across the country. Her working methods and philosophy are shown in the book *The Figure in Clay: Contemporary Sculpting Techniques by Master Artists* (Lark Books, 2005). Her work has been featured in selective exhibitions and is included in important national and international collections.

mark newport

Born in 1964 in Amsterdam, New York, Mark Newport learned to knit as a child from his grandmother. He later learned simple weaving techniques while in Brazil as a high school exchange student and went on to study at the Kansas City Art Institute, graduating with a B.F.A. in 1986. When Newport returned to school, earning an M.F.A. from the School of the Art Institute of Chicago in 1991, his thesis show featured knotted sculptures inspired by the figure.

While teaching at Western Washington University in Bellingham, Newport re-learned knitting in order to share the technique with his students. By 2002, he moved into knitting in his own art, and the superhero series was born. While teaching at Arizona State University, Newport incorporated aspects of performance in his work, staging photographs and videos that portray him in his knitted suits. Prints that evoke comic books also followed.

In 2007, Mark Newport was appointed artist-in-residence and head of the Fiber Department at the Cranbrook Academy of Art, Bloomfield Hills, Michigan. His work has been exhibited throughout the United States, Canada, and Europe and is in the permanent collections of the Whitney Museum of American Art in New York City and the Racine Art Museum in Wisconsin.

mary van cline

Mary Van Cline grew up in Dallas, Texas, her 1954 birthplace. She graduated from North Texas University with a B.F.A. in art and architecture in 1976, completing a master's in art in 1977. She credits her introduction to glass to her experiences at the influential Penland School of Crafts in North Carolina in 1979. Van Cline further developed her knowledge of glass techniques at Massachusetts College of Art and Design in Boston, where she earned her M.F.A. in 1982. It was there she also became intrigued by the possibilities of light, experimenting with prisms and photosensitive glass.

Extensive travel has been inextricably intertwined with her artistic development. One of the earliest of these important journeys was a stay on the island of Crete in 1986. Perhaps most influential was Van Cline's six-month residency in Japan sponsored by the Japan-United States Friendship Commission and the National Endowment for the Arts. Photographic series created during these travels serve as a rich resource to be examined and re-examined, and the arts of Japan, including *butoh* theater, have had a lasting impact.

Technical experimentation with photography and light-sensitive surfaces has earned Van Cline a reputation for cutting-edge innovation. But her work is not limited to this combination, and she uses other glass techniques such as pâte de verre to create three-dimensional figures and objects based on her photographic images. She has taught classes at Pilchuck Glass School, Penland School of Crafts, and Rhode Island School of Design. Her work is included in both private collections and major museums, including the Corning Museum of Glass. Van Cline maintains her studio in Seattle, Washington.

sunkoo yuh

SunKoo Yuh's artistic journey began in South Korea, where he was born in 1960. His creative talents emerged in early childhood as he became proficient in drawing. His aptitude gained him entry into the selective art school at Hongik University in Seoul, where he studied ceramics and learned to paint and draw, earning a B.F.A. degree in 1988.

After Yuh's sister immigrated to the United States to study, he followed her and settled in California. His earlier artistic patterns were shattered when he undertook studies with Tony Marsh at the California State University, Long Beach, where he developed expertise in working with porcelain and high-fire glazes and created a portfolio that earned him entrance into the School of Art and Design at the renowned New York State College of Ceramics at Alfred University in New York. There he studied with noted ceramic faculty that included the artist Wayne Higby and received an M.F.A in 1997.

Yuh's work won the grand prize in the second World Ceramic Biennale 2003 Korea International Competition, and in 2006 he was awarded a grant in sculpture from the Joan Mitchell Foundation. Now an associate professor of ceramics at the Lamar Dodd School at the University of Georgia in Athens, he continues to learn and experiment. Exhibitions have brought him to the attention of curators and collectors, and his work is included in important private and public collections, including the Renwick Gallery of the Smithsonian American Art Museum, the Schein-Joseph International Museum of Ceramic Art in Alfred, New York, and the Museum of Fine Arts, Houston.

exhibition checklist

christyl boger

Weekend State, 2005
glazed white earthenware with gold luster
30 x 18 x 18 in.
Collection of Laura Lee Brown and
Steve Wilson; Louisville, Kentucky

Float, 2006
glazed white earthenware with gold luster
32 x 22 x 22 in.
Collection of Laura Lee Brown and
Steve Wilson; Louisville, Kentucky

Figure with Dolphin, 2007
glazed white earthenware with gold luster
27 x 24 x 18 in.
Collection of the artist

Sea Toy, 2007
glazed white earthenware with gold luster
28 x 26 x 16 in.
Collection of Laura Lee Brown and
Steve Wilson; Louisville, Kentucky

Waterwings, 2007
glazed white earthenware with gold luster
26 x 20 x 20 in.
Collection of Laura Lee Brown and
Steve Wilson; Louisville, Kentucky

Day and Night, 2008
glazed white earthenware with gold luster
26 x 54 x 19 in.
Collection of the artist

Figure with Sea Dragon, 2008
glazed white earthenware with gold luster
27 x 20 x 16 in.
Collection of the artist

Night and Day, 2008
glazed white earthenware with gold luster
26 x 54 x 19 in.
Collection of the artist

mark newport

Raw Hide Kid, 2004
acrylic yarn and buttons
72 x 26 x 6 in.
Courtesy of the Greg Kucera Gallery

Batman 2, 2005
acrylic yarn and buttons
72 x 26 x 6 in.
Courtesy of the Greg Kucera Gallery

Batmen, 2005
photo inkjet print on paper
13 x 19 in.
Courtesy of the Greg Kucera Gallery

Button Up, 2005
photo inkjet print on paper
13 x 19 in.
Courtesy of the Greg Kucera Gallery

Every-Any-No Man, 2005
acrylic yarn and buttons
120 x 26 x 6 in.
Courtesy of the Greg Kucera Gallery

He Could Help, 2005
photo inkjet print on paper
13 x 19 in.
Courtesy of the Greg Kucera Gallery

Knitting a Forcefield I, 2005
photo inkjet print on paper
19 x 13 in.
Courtesy of the Greg Kucera Gallery

Real Me, 2005
photo inkjet print on paper
19 x 13 in.
Courtesy of the Greg Kucera Gallery

Reflection (Fantastic Four in Mirror), 2005
photo inkjet print on paper
19 x 13 in.
Courtesy of the Greg Kucera Gallery

Sweaterman 3, 2005
acrylic yarn and buttons
72 x 26 x 6 in.
Courtesy of the Greg Kucera Gallery

Training, 2005
photo inkjet print on paper
19 x 13 in.
Courtesy of the Greg Kucera Gallery

Wardrobe, 2005
photo inkjet print on paper
13 x 19 in.
Courtesy of the Greg Kucera Gallery

Bobbleman, 2006
acrylic yarn and buttons
72 x 26 x 6 in.
Courtesy of the Greg Kucera Gallery

Freedom Bedcover: Zachary, 2006
comic book pages, embroidery, and satin trim
84 x 65 in.
Courtesy of the Greg Kucera Gallery

Two Gun Kid, 2006
acrylic yarn and buttons
72 x 26 x 6 in.
Courtesy of the Greg Kucera Gallery

Heroic Efforts, 2007, DVD
3 minutes, 19 seconds
Courtesy of the Greg Kucera Gallery

mary van cline

The Listening Point, 1993
photosensitive glass, wood, and metal
72 x 108 x 96 in.
Courtesy of Leo Kaplan Modern

The Listening Point, 1999
photosensitive glass and pâte de verre
25½ x 20¼ x 4 in.
Smithsonian American Art Museum,
Gift of the James Renwick Alliance, 1999.38

Cycles of Relationship of Time, 2000
photosensitive glass, pâte de verre,
and bronze patina
25 x 26 x 6 in.
Private collection

The Ocean of Memory Within, 2008
photosensitive glass and pâte de verre
30 x 60 x 6 in.
Ms. Patricia Schaefer and Mrs. Tove Stimson

Healing Passage of Time, 2008
photosensitive glass
two panels, each 72 x 60 x 4 in.
Collection of the artist

Winter Ice Branches, 2008
ivory pâte de verre
each branch 24 x 11 x 90 in.
Collection of the artist

sunkoo yuh

Memory of Pikesville, TN, 2003
glazed porcelain
34 x 29 x 26 in.
Collection of the artist

False Start, 2006
glazed porcelain
31 x 22 x 18 in.
Collection of the artist

One More Chance, 2006
glazed porcelain
29 x 28 x 24 in.
Collection of the artist

Anniversary, 2007
glazed stoneware
31 x 16 x 14 in.
Collection of Helen Williams Drutt English
and H. Peter Stern

Can You Hear Me?, 2007
glazed porcelain
27 x 22 x 17 in.
Collection of the artist

Family Guardian, 2007
ink on *hanji* (Korean paper)
25 x 37 in.
Collection of the artist

Fortune Pig, 2007
glazed porcelain
25 x 16 x 15 in.
Collection of the artist

Guardian Dragon, 2007
ink on *hanji* (Korean paper)
25½ x 38½ in.
Collection of the artist

Human Cliff, 2007
ink on *hanji* (Korean paper)
25½ x 37 in.
Collection of the artist

I Want to Know You Better, 2007
ink on *hanji* (Korean paper)
25½ x 28½ in.
Collection of the artist

Just You and Me, 2007
ink on *hanji* (Korean paper)
25½ x 38½ in.
Collection of the artist

Leaner, 2007
glazed porcelain
37 x 26 x 22 in.
Collection of the artist

Need Sacrifice, 2007
ink on *hanji* (Korean paper)
25½ x 37½ in.
Collection of the artist

Party Time, 2007
ink on *hanji* (Korean paper)
25 x 38½ in.
Collection of the artist

Sacrifice, Need Everywhere, 2007
glazed porcelain
29 x 18 x 17 in.
Collection of the artist

Sinner, 2007
ink on *hanji* (Korean paper)
25½ x 38½ in.
Collection of the artist

Time to Go, 2007
ink on *hanji* (Korean paper)
25½ x 38½ in.
Collection of the artist

Candle and Sunflower, 2008
ink on *hanji* (Korean paper)
25½ x 38½ in.
Collection of the artist

Circle of Eyes, 2008
ink on *hanji* (Korean paper)
25½ x 37 in.
Collection of the artist

Cortona Summer, 2008
ink on *hanji* (Korean paper)
25½ x 37 in.
Collection of the artist

From a Distance, 2008
ink on *hanji* (Korean paper)
25½ x 37½ in.
Collection of the artist

GULDAGERGAARD, 2008
ink on *hanji* (Korean paper)
25½ x 37 in.
Collection of the artist

Hope Blower, 2008
ink on *hanji* (Korean paper)
25½ x 37 in.
Collection of the artist

May I Lick You?, 2008
ink on *hanji* (Korean paper)
25½ x 37½ in.
Collection of the artist

Old and New, 2008
ink on *hanji* (Korean paper)
25½ x 37 in.
Collection of the artist

Roman Influence, 2008
ink on *hanji* (Korean paper)
25½ x 38½ in.
Collection of the artist

Where We Going?, 2008
ink on *hanji* (Korean paper)
25½ x 38½ in.
Collection of the artist

Wiseman's Tear, 2008
ink on *hanji* (Korean paper)
25½ x 38½ in.
Collection of the artist

notes

1 Michael Fried, *Art and Object-hood: Essays and Reviews* (Chicago: University of Chicago Press, 1998), 155.

2 Alisa Solomon, *Re-Dressing the Canon: Essays on Theater and Gender* (New York: Routledge, 1997), 13.

3 Fried, 155.

4 Christyl Boger, interview with the author in the artist's studio at Indiana University, Bloomington, January 30, 2008. Unless otherwise noted, all quotations by Boger are culled from this interview.

5 Christyl Boger, *Chymical Object* exhibition pamphlet, The Clay Studio, September 2001.

6 Fried, 154.

7 Griselda Pollock, *Encounters in the Virtual Feminist Museum: Time, Space and the Archive* (New York: Routledge, 2007), 67. The Henry Moore Institute and the Freud Museum organized and exhibited *Freud's Sculpture*, a 2006 show featuring works that populated Sigmund Freud's desk.

8 Ibid., 69.

9 Les Essif, *Empty Figure on an Empty Stage: The Theatre of Samuel Beckett and His Generation* (Bloomington: Indiana University Press, 2001), 7–9.

10 Earthenware's lower firing temperature requires less support in the kiln than does porcelain. In addition, the glaze sits on the surface of the clay rather than bonding fully and becoming integral to it, which is typical of high-fire glazes. This technical detail supports Boger's interest in surface and artifice.

11 For more information on historical court ceramics, see *World Ceramics* (New York: Crown Publishers, 1990).

12 Solomon, 1.

13 The exhibition *Venus and Love: Michelangelo and the New Ideal of Beauty*, reviewed by Alan Riding, "In Florence, Michelangelo Has His Moment; Three Exhibitions Explore How the Master Influenced Art and the Notion of Beauty," *New York Times*, August 20, 2002.

14 American superheroes garnered an international audience and fostered cross-cultural spin-offs, especially in Japan, where Astro Boy and Ultraman save the good from evil.

15 Newport has performed in costume at the Scottsdale Museum of Contemporary Art (Scottsdale, Arizona, November 2006), Housing Projects (Phoenix, Arizona, May 2007), and the Stanlee and Gerald Rubin Center for the Visual Arts at the University of Texas at El Paso (El Paso, Texas, April 2008). *The Scout* (see discussion, p. 39) was photographed in the Arizona desert, where bypassers could stop and observe.

16 Ruth La Ferla, "The Knitting Circle Shows Its Chic," *New York Times*, July 12, 2007. Today many artists knit not only for the love of making, but also as a political or subversive act. Knitta Please, for example, is a Houston-based group of anonymous women who tag urban spaces with knitted objects. Artist Lisa Anne Auerbach sponsors an online journal, *The Little Red Blog of Revolutionary Knitting*. Her recent *Body Count Mittens* document American casualties in Iraq. Newport also addresses violence by making us aware that comics, movies, and television are propagators of fantasy and false security in an increasingly violent world.

17 Mark Newport, interview with the author in the artist's studio at Cranbrook Academy of Art, Bloomfield Hills, Michigan, February 1, 2008. Unless otherwise noted, all quotations by Newport are culled from this interview.

18 Van Cline acknowledges her intentionality in staging. "I present theater in my work. There is usually a story, a scene, a stage, and lighting. I build theater sets from my photos." Mary Van Cline, quoted in Ron Glowen, "Mary

Van Cline: Time Pieces," *American Craft* 58 (Oct./Nov. 1998): 44. Some of today's best-recognized photographers, such as Gregory Crewdson and Tina Barney, create psychologically tense scenes by staging actors within specific environments. Crewdson's settings are built especially for his photographs, which, like Van Cline's, convey characters that seem emotionally isolated from each other. Van Cline employs similar subject matter but reverses its action: her photos become stage sets rather than photos depicting stage sets. See Tina Barney and Andy Grundberg, *Tina Barney Photographs: Theater of Manners* (Zurich and New York: Scalo, 1997) and Stephan Berg and others, *Gregory Crewdson 1985–2005* (Stuttgart: Hatje Cantz, 2005).

19 Ancient Greek theater also depended upon female impersonation. See Solomon, 1.

20 Mitsuhiro Yoshimoto, *Kurosawa: Film Studies and Japanese Cinema* (Durham, NC: Duke University Press, 2000), 182–89.

21 Mary Van Cline, interview with the author at the artist's studio, Seattle, Washington, February 15, 2008.

22 John E. Ho, *East Asian Philosophy: With Historical Background and Present Influence* (New York: Peter Lang, 1992), 40.

23 The ladder in the large version of *The Listening Point*, like the portal in *Cycles of Relationship of Time*, serves as a metaphorical entry point into the unknown.

24 SunKoo Yuh, interview with the author in the artist's studio at the University of Georgia in Athens, January 26, 2008. Unless otherwise noted, all quotations by Yuh are culled from this interview.

25 Jerome P. Crabb, "Theatre of the Absurd," Theatre Database, http://www.theatredatabase.com/20th_century/theatre_of_the_absurd.html (accessed November 12, 2008).

26 Peter Selz, *Max Beckmann: The Self-Portraits* (New York: Rizzoli, 1992), 12.

image credits

christyl boger
Frontispiece: photo by Gene Young
Pages 16, 18–20, 22–28: photos by Gene Young
Page 29: photo by Michael Cavanagh and Kevin Montague
Page 72: artist in studio. Photo by John Burgoon, courtesy of the artist.

mark newport
Back cover: photo by Gene Young
Pages 30, 32, 34, 36–37, 40–41: photos by Gene Young
Pages 33, 35, 38, 42–43: digital images by artist
Page 73: artist knitting in his studio, 2008. Photo courtesy of the artist.

mary van cline
Front cover: photo by Rob Vinnedge
Pages 44, 46–47, 51–54: photos by Rob Vinnedge
Pages 48, 55: photos by Gene Young
Page 74: artist photographing on location. Photo courtesy of the artist.

sunkoo yuh
Foreword: photo by Gene Young
Pages 56, 58–59, 61, 65–69, 71: photos by Gene Young
Pages 62–63: photos by Anthony Cunha
Page 75: artist in studio, 2008. Photo by Adam Gruszynski, courtesy of the artist.

selected bibliography

Barney, Tina, and Andy Grundberg. *Tina Barney: Theater of Manners.* Zurich and New York: Scalo, 1997.

Berg, Stephan, Martin Hochleitner, and Katy Siegel. *Gregory Crewdson 1985–2005.* Stuttgart: Hatje Cantz, 2005.

Boger, Christyl. *Chymical Object.* (exhibition brochure) Philadelphia, PA: The Clay Studio, 2001.

Bonansinga, Kate. *Full and Spare: Ceramics in the 21st Century.* Tallahassee: Florida State University Museum of Fine Arts, 2008.

Bonansinga, Kate, and Peter Held. *A Human Impulse: Figuration from the Diane and Sandy Besser Collection.* Tempe: Arizona State University Art Museum, 2008.

Bonansinga, Kate, Diana Natalicio, and Stephanie L. Taylor. *Unknitting: Challenging Textile Traditions.* El Paso: University of Texas at El Paso, 2008.

Burkett, Richard. *Masters: Porcelain: Major Works by Leading Ceramists.* Asheville, NC: Lark Books, 2008.

English, Helen Drutt, Wayne Higby, and Tony Marsh. *SunKoo Yuh: Along the Way.* Philadelphia: Philadelphia Art Alliance, 2007.

Essif, Les. *Empty Figure on an Empty Stage: The Theatre of Samuel Beckett and His Generation.* Bloomington: Indiana University Press, 2001.

Frantz, Susanne K. *Contemporary Glass: A World Survey from the Corning Museum of Glass.* New York: Abrams, 1989.

Frantz, Susanne, Ron Glowen, Tom Philabaum, and Joanne Stuhr. *¡Cálido!: Contemporary Warm Glass.* Tucson, AZ: Tucson Museum of Art, 1997.

Fried, Michael. *Art and Objecthood: Essays and Reviews.* Chicago: University of Chicago Press, 1998.

Glowen, Ron. "Mary Van Cline: Time Pieces." *American Craft* 58 (October–November 1998): 44–46.

Gunter, Veronika Alice, ed. *500 Figures in Clay: Ceramic Artists Celebrate the Human Form.* Asheville, NC: Lark Books, 2004.

Ho, John E. *East Asian Philosophy: With Historical Background and Present Influence.* New York: Peter Lang, 1992.

Littleton, Maurine. *500 Glass Objects: A Celebration of Functional and Sculptural Glass.* Asheville, NC: Lark Books, 2006.

Miller, Bonnie J., and Robert Lyons. *Out of the Fire: Contemporary Glass Artists and Their Work.* San Francisco: Chronicle Books, 1991.

Milosch, Jane, and Susanne Frantz. *From the Ground Up: Renwick Craft Invitational 2007.* Washington, DC: Smithsonian American Art Museum, 2007.

Pollock, Griselda. *Encounters in the Virtual Feminist Museum: Time, Space and the Archive.* New York: Routledge, 2007.

Quinton, Sarah. *Close to You: Contemporary Textiles, Intimacy and Popular Culture.* Toronto: Dalhousie Art Gallery and Textile Museum of Canada, 2008.

Selz, Peter. *Max Beckmann: The Self-Portraits.* New York: Rizzoli, 1992.

Smith, Paul J., and Akiko Busch. *Objects for Use: Handmade by Design.* New York: Abrams in association with the American Craft Museum, 2001.

Smith, Paul J., and Edward Lucie-Smith. *American Craft Today: Poetry of the Physical.* New York: Weidenfeld & Nicolson in association with the American Craft Museum, 1986.

Solomon, Alisa. *Re-Dressing the Canon: Essays on Theater and Gender.* New York: Routledge, 1997.

Spiak, John D. *Mark Newport: Super Heroics.* Tempe: Arizona State University Art Museum, 2005.

Tourtillott, Suzanne J. E., ed. *The Figure in Clay: Contemporary Sculpting Techniques by Master Artists.* Asheville, NC: Lark Books, 2005.

Ward, Gerald W. R., Julie Muñiz, and Matthew Kangas. *Shy Boy, She Devil and Isis: The Art of Conceptual Craft: Selections from the Wornick Collection.* Boston: MFA Publications, 2007.

Yoshimoto, Mitsuhiro. *Kurosawa: Film Studies and Japanese Cinema.* Durham, NC: Duke University Press, 2000.

Zilber, Emily. *Mark Newport: Superheroes in Action.* Bloomfield Hills, MI: Cranbrook Art Museum, 2009.